Studies in Mixed Media

Figures and Designs for the Month of June 2013

By Benjamin Long.

```
Illustrations by Benjamin Long for the Month of June.  New
Illustrations and commission work that was requested of me.
Many pieces feature the cartoon/ cross hatch style that I have
been working on as well as a few underpaints.
```

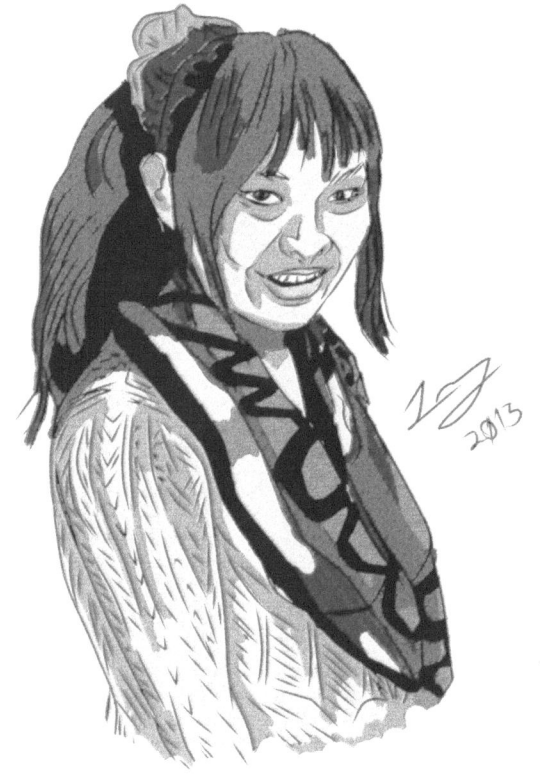
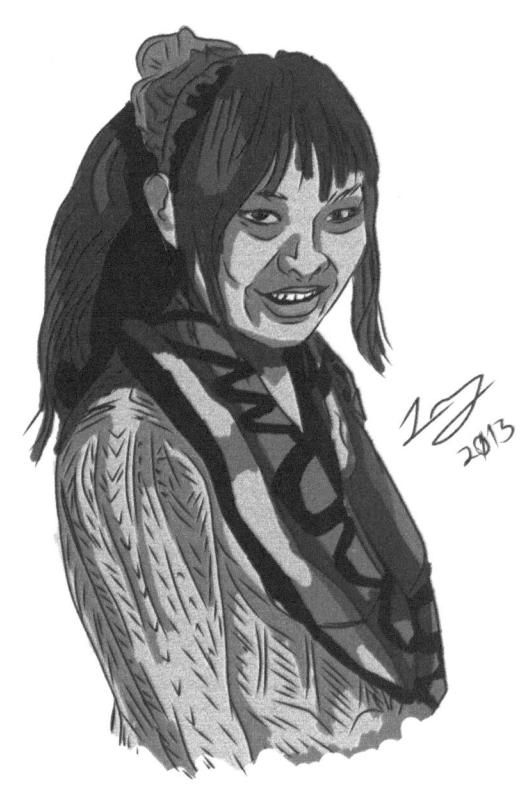

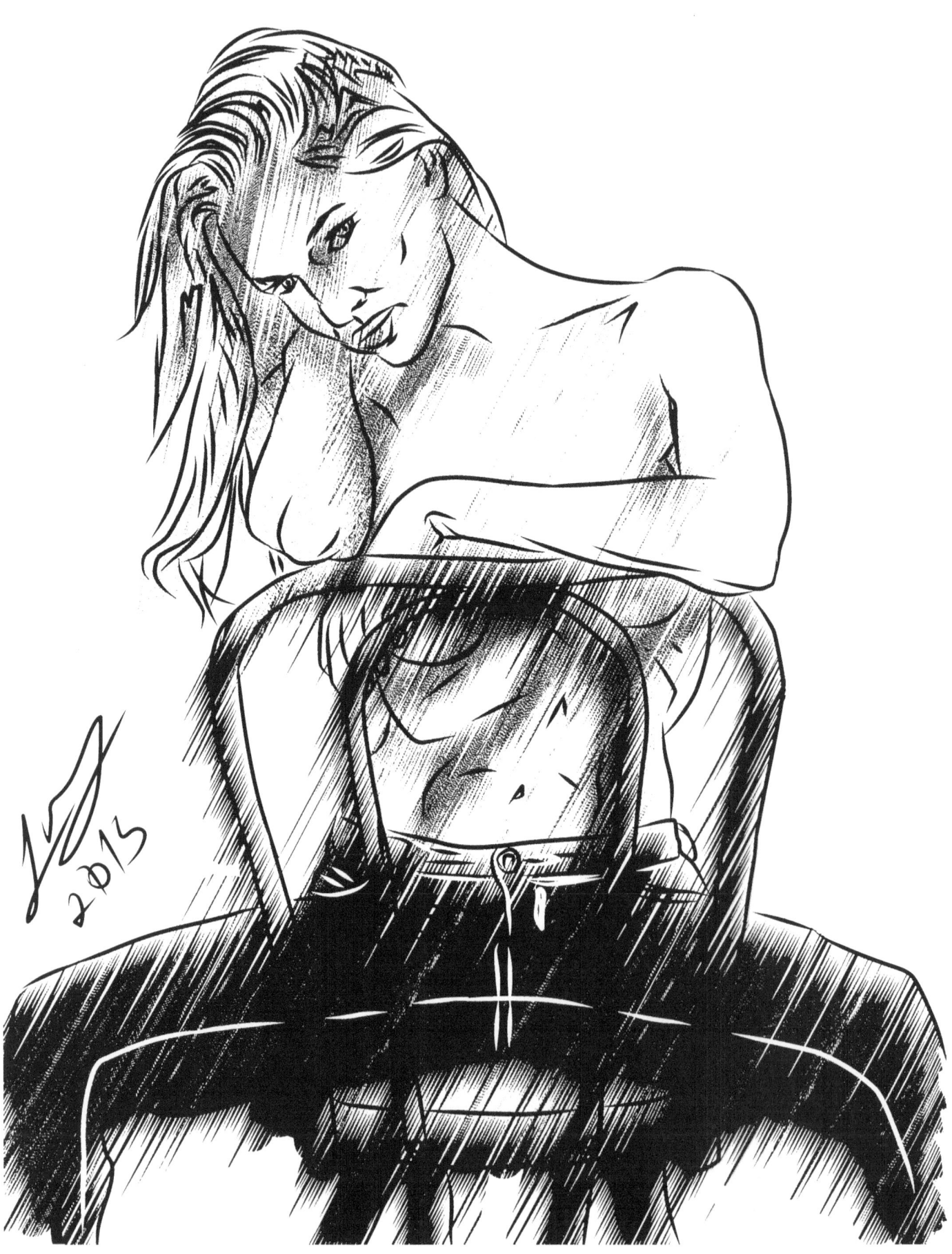

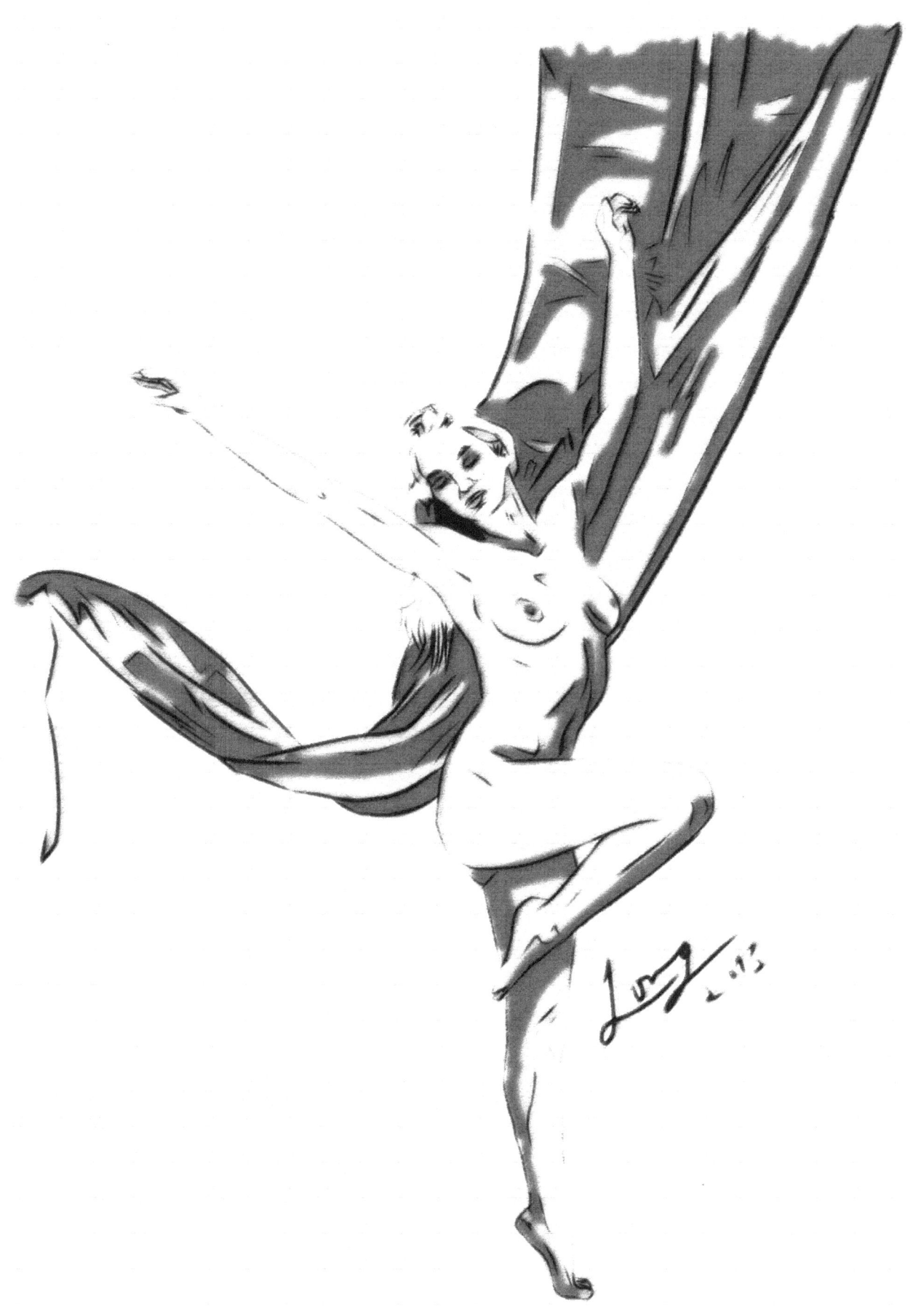

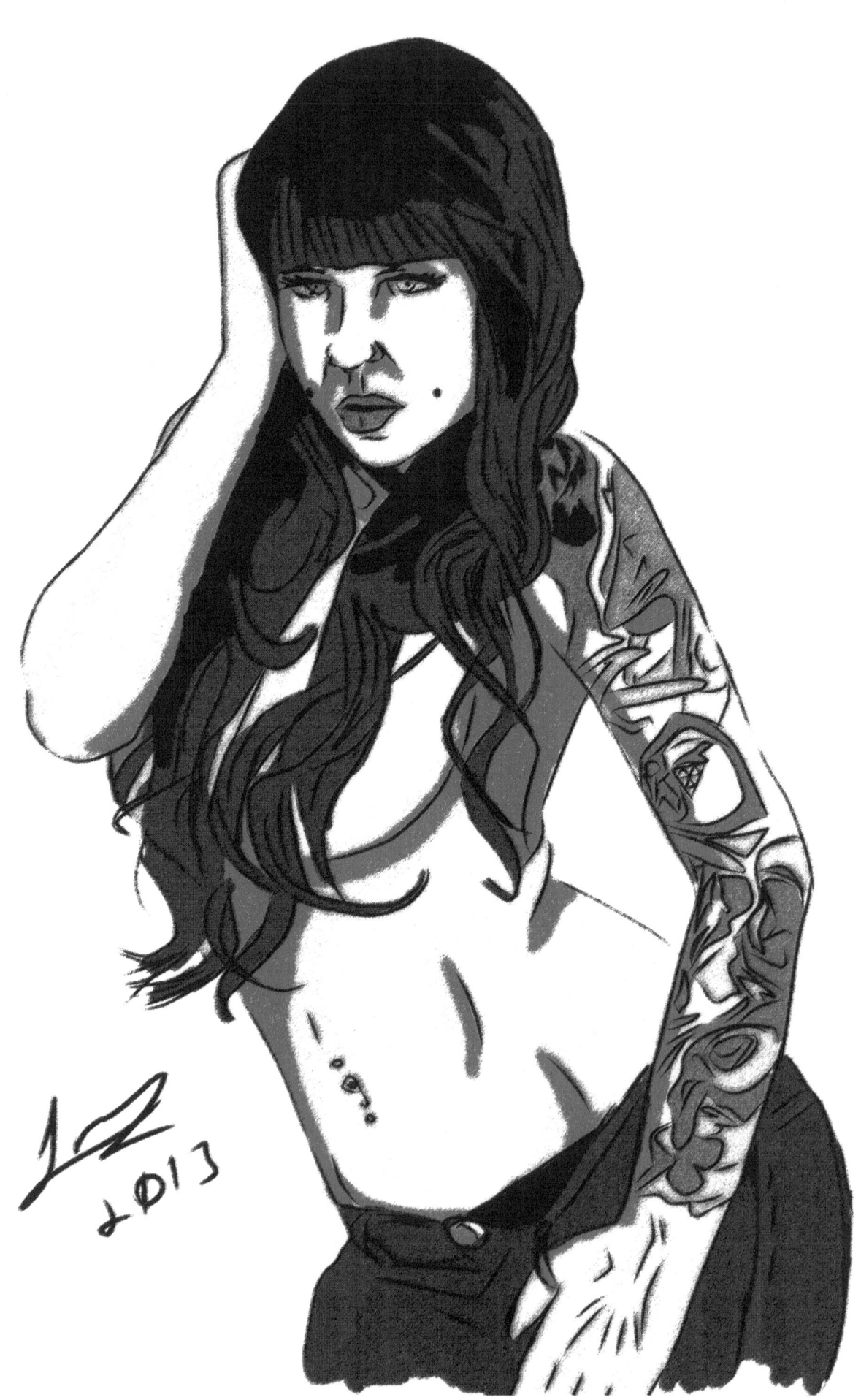

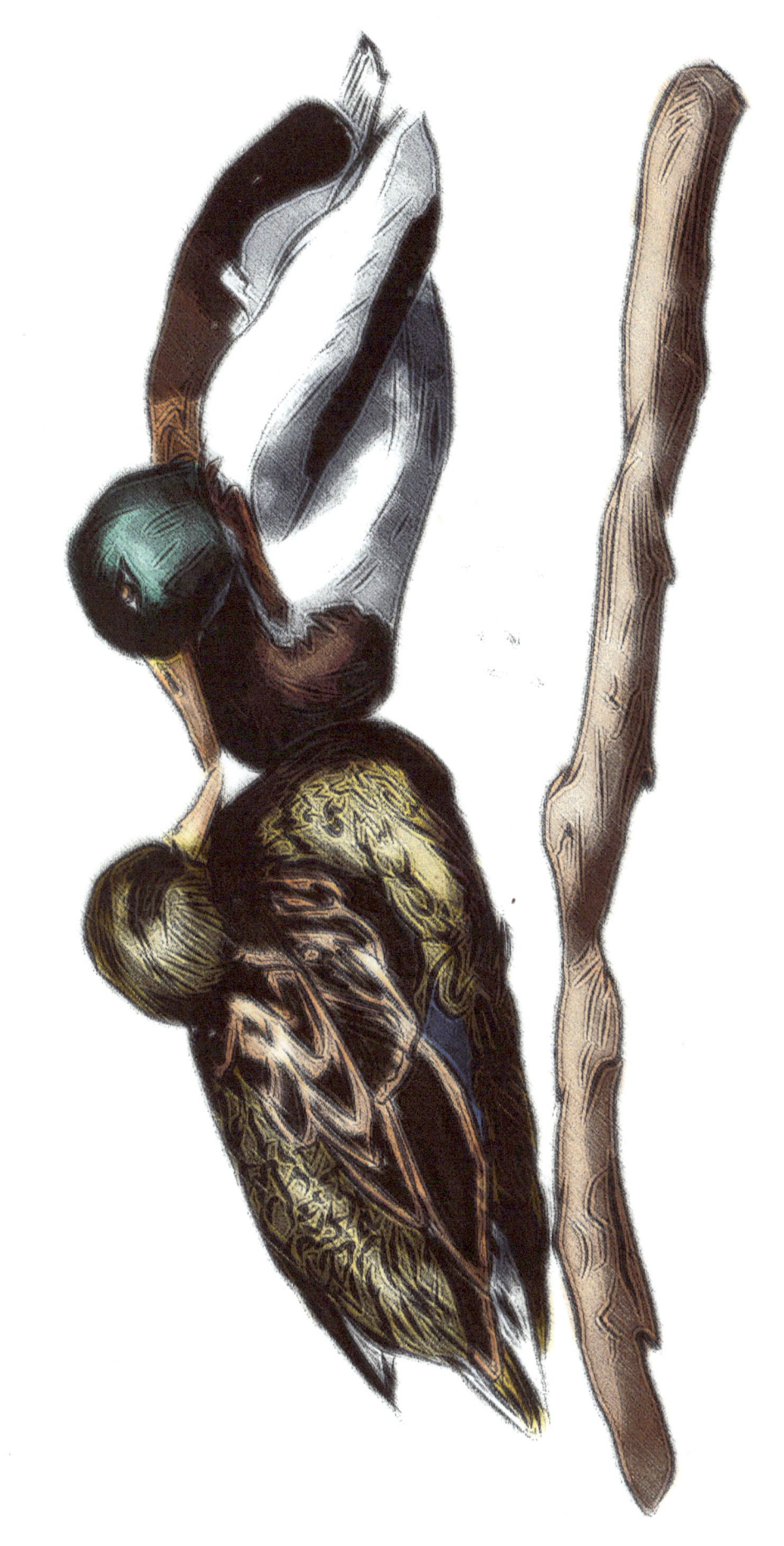

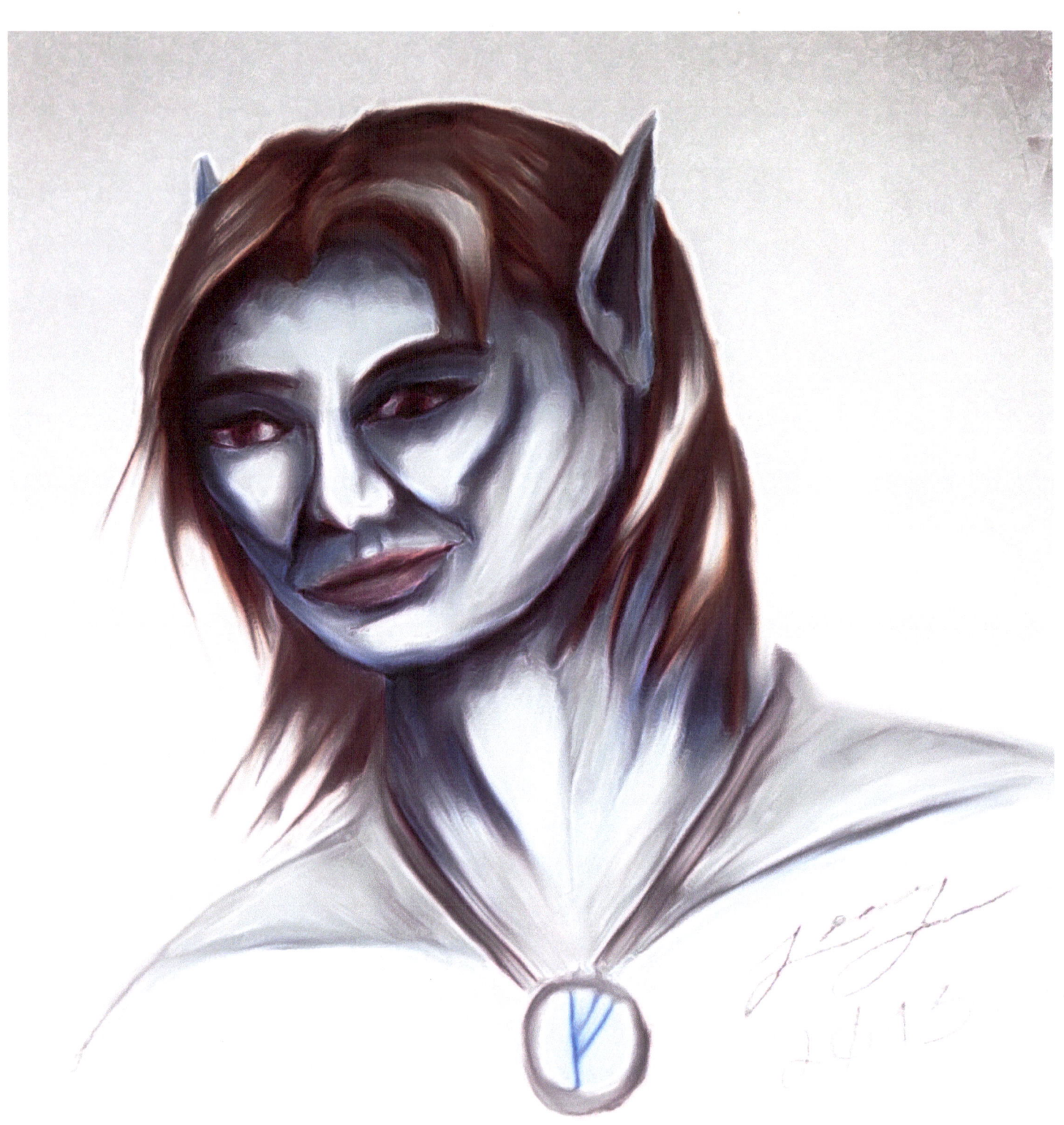

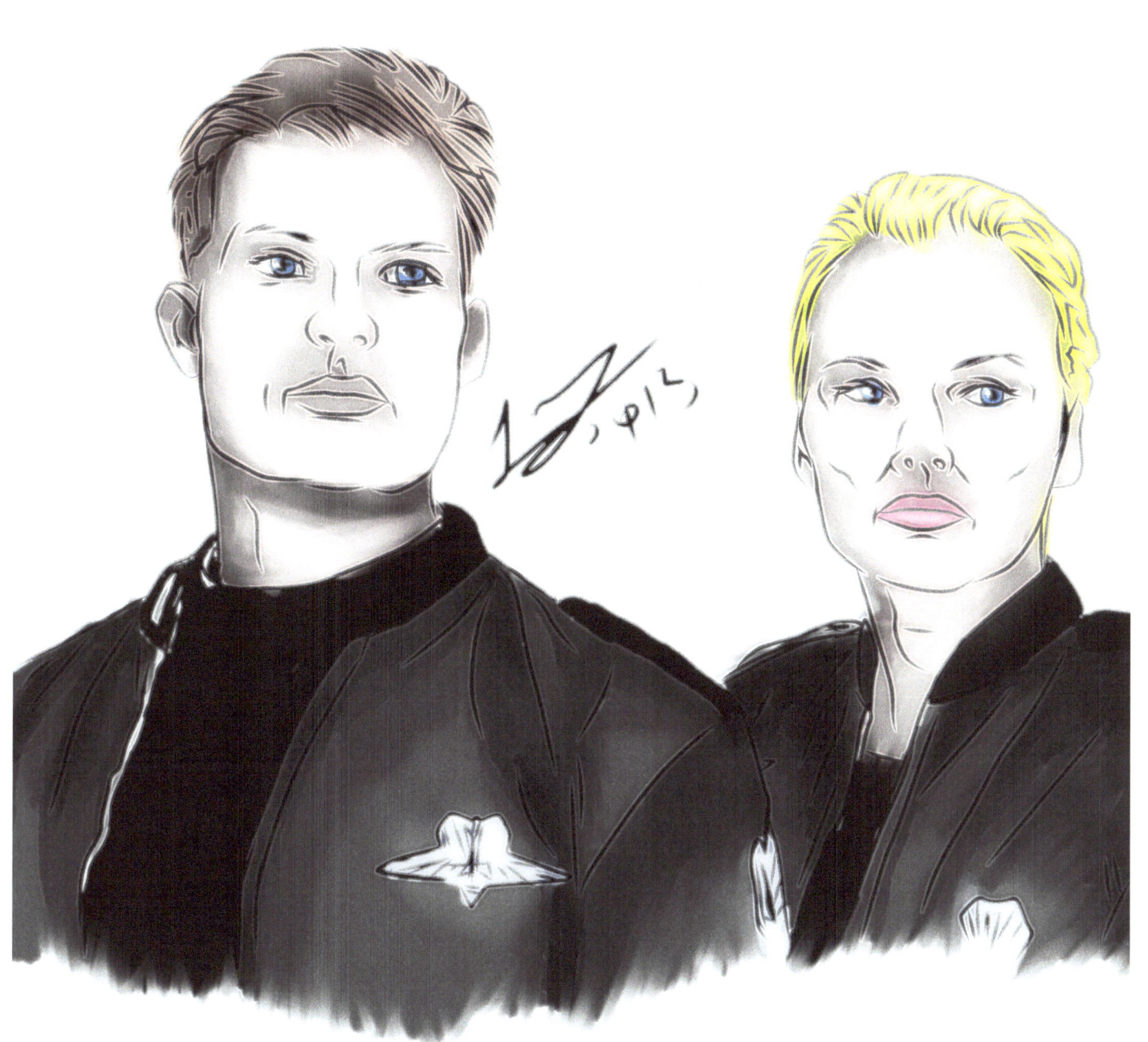

ARE YOU A CITIZEN?
DO YOU HAVE WHAT IT TAKES?

Suspect 1

Suspect 2

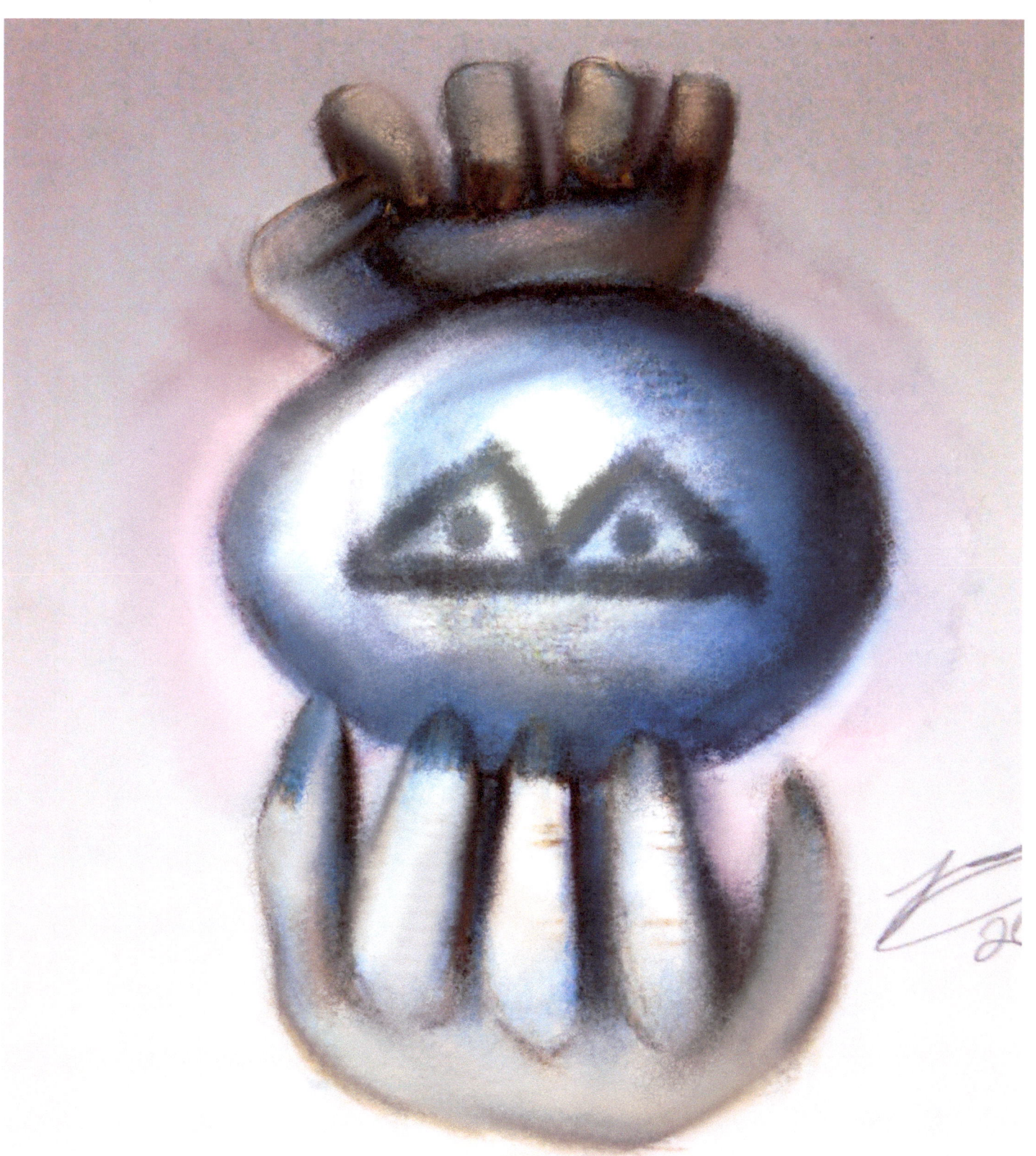

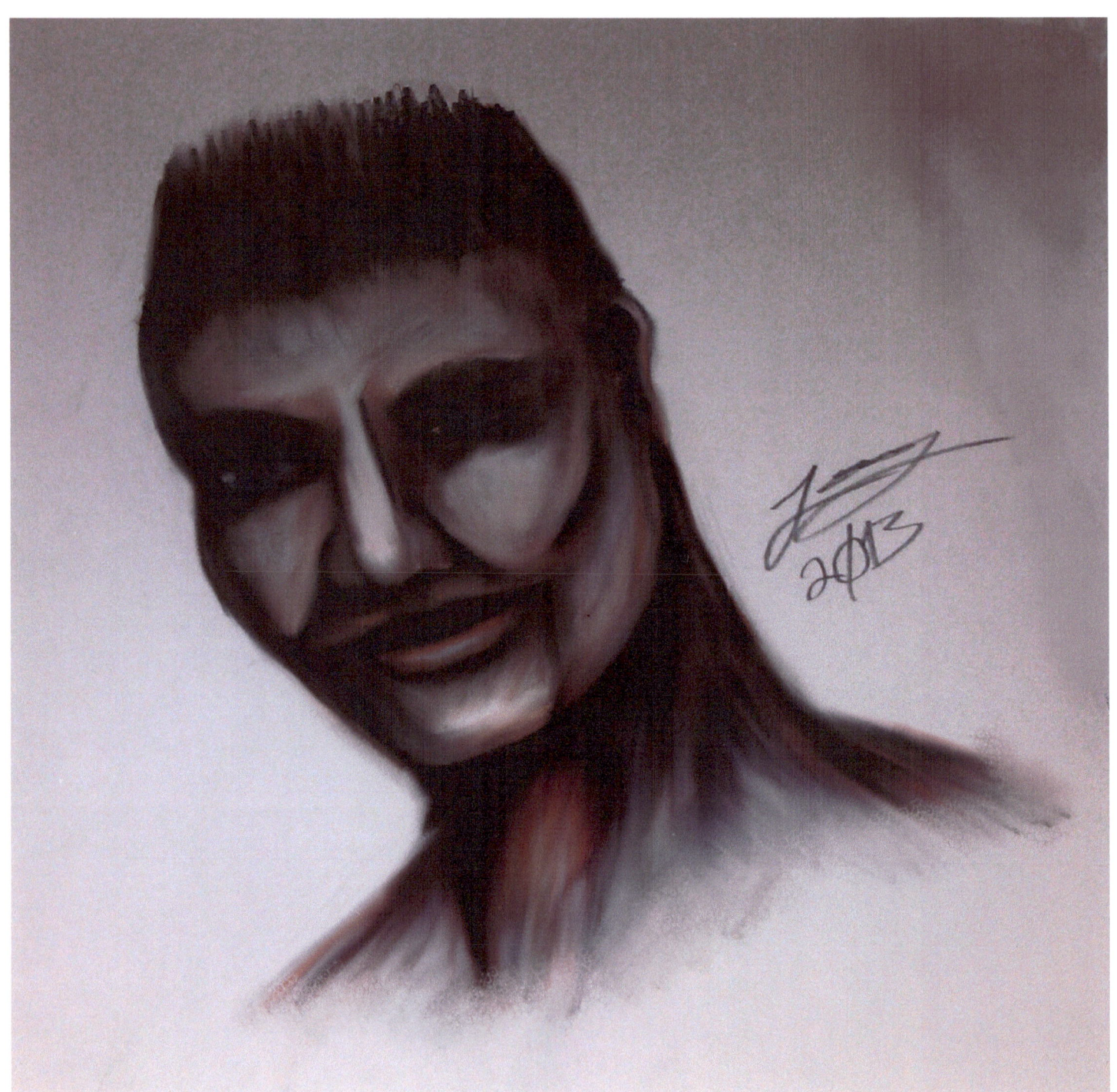

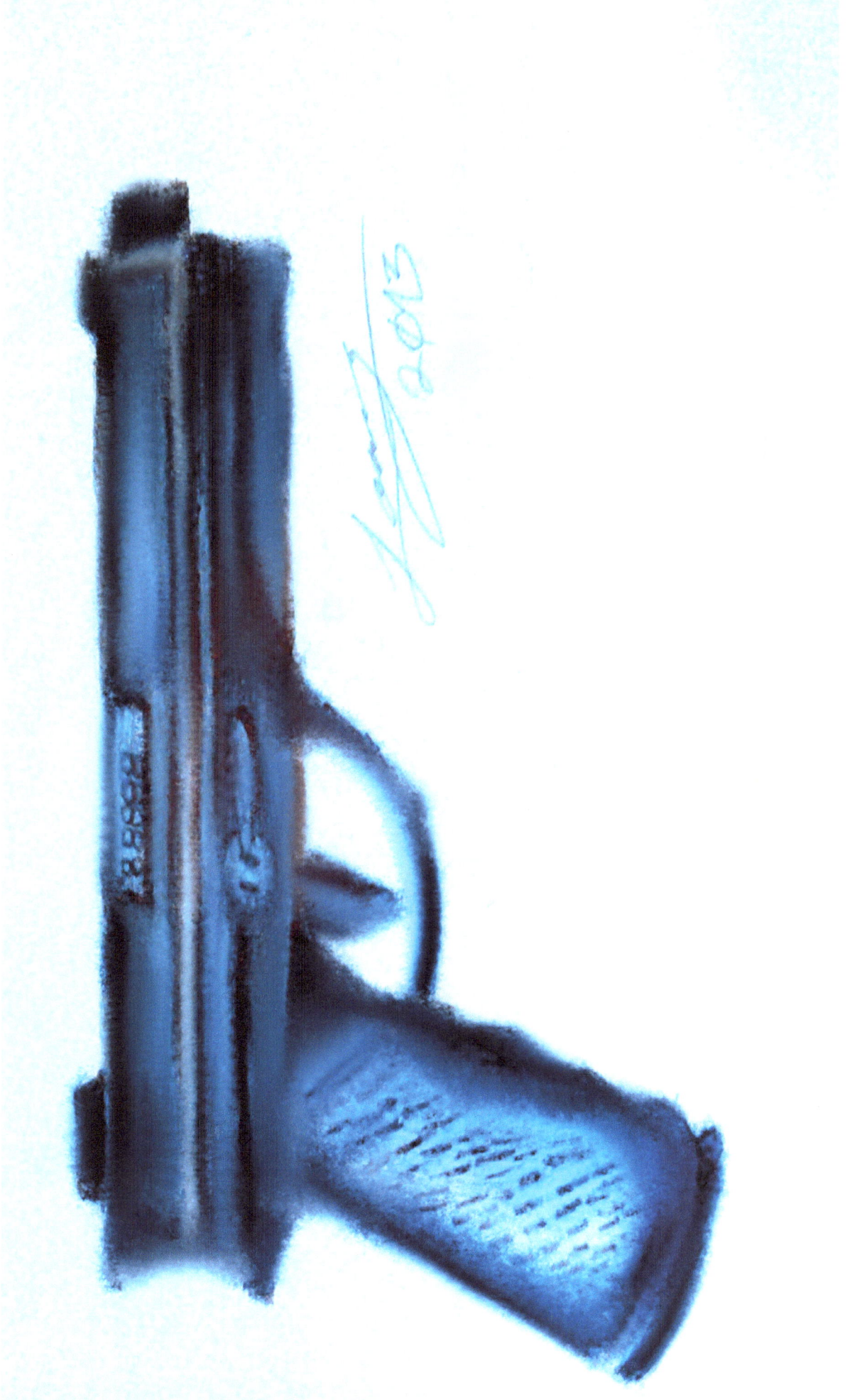

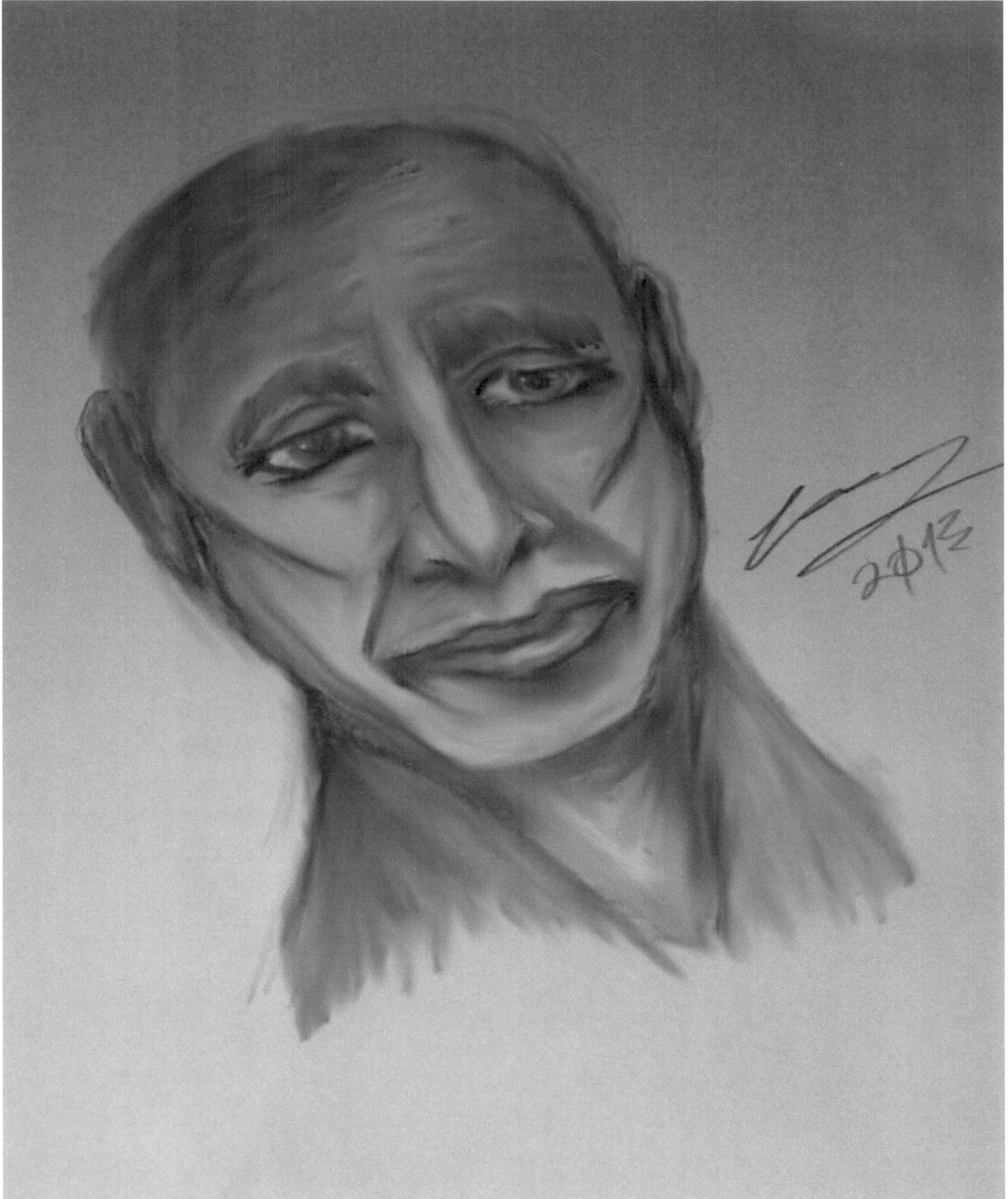

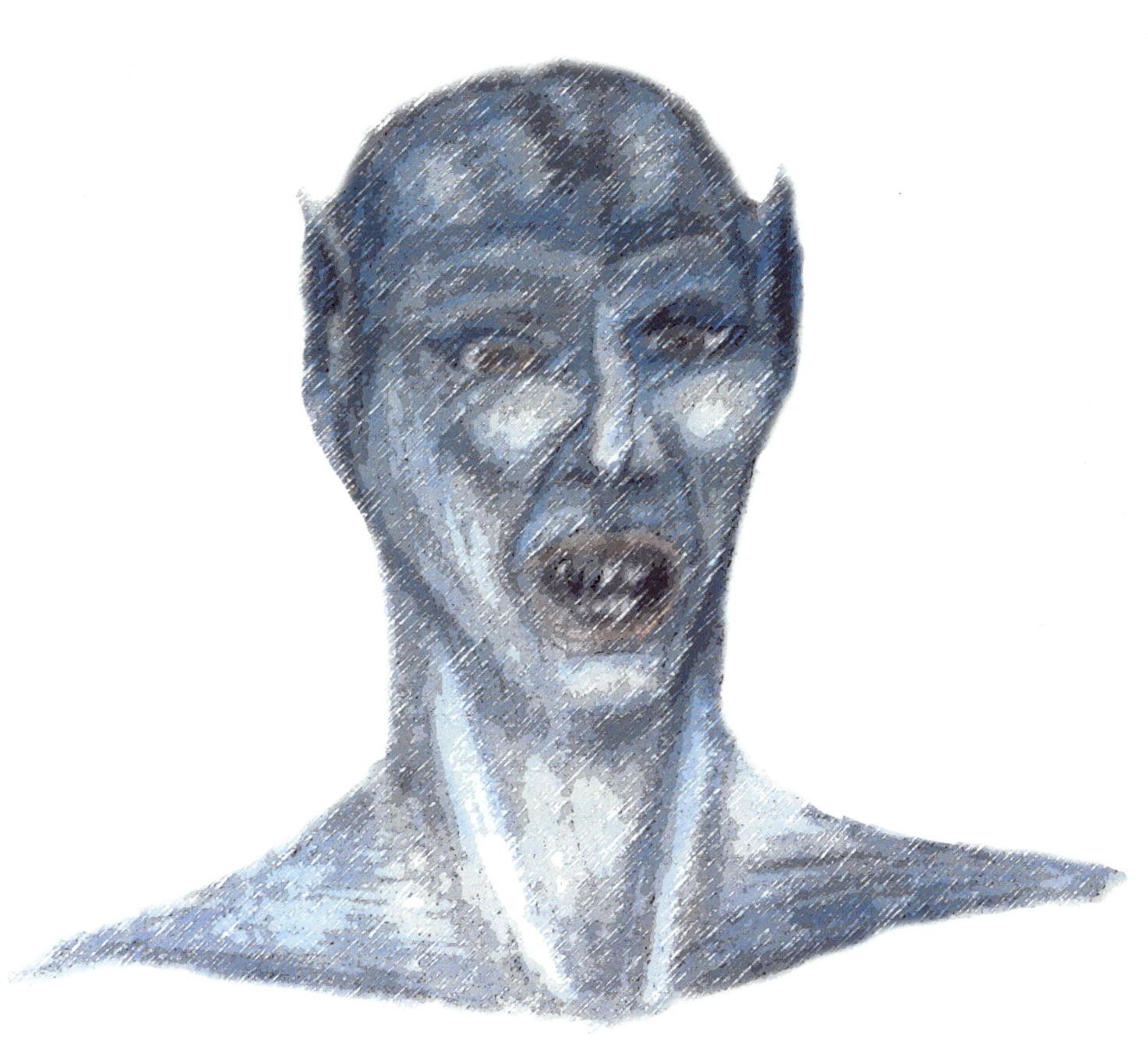

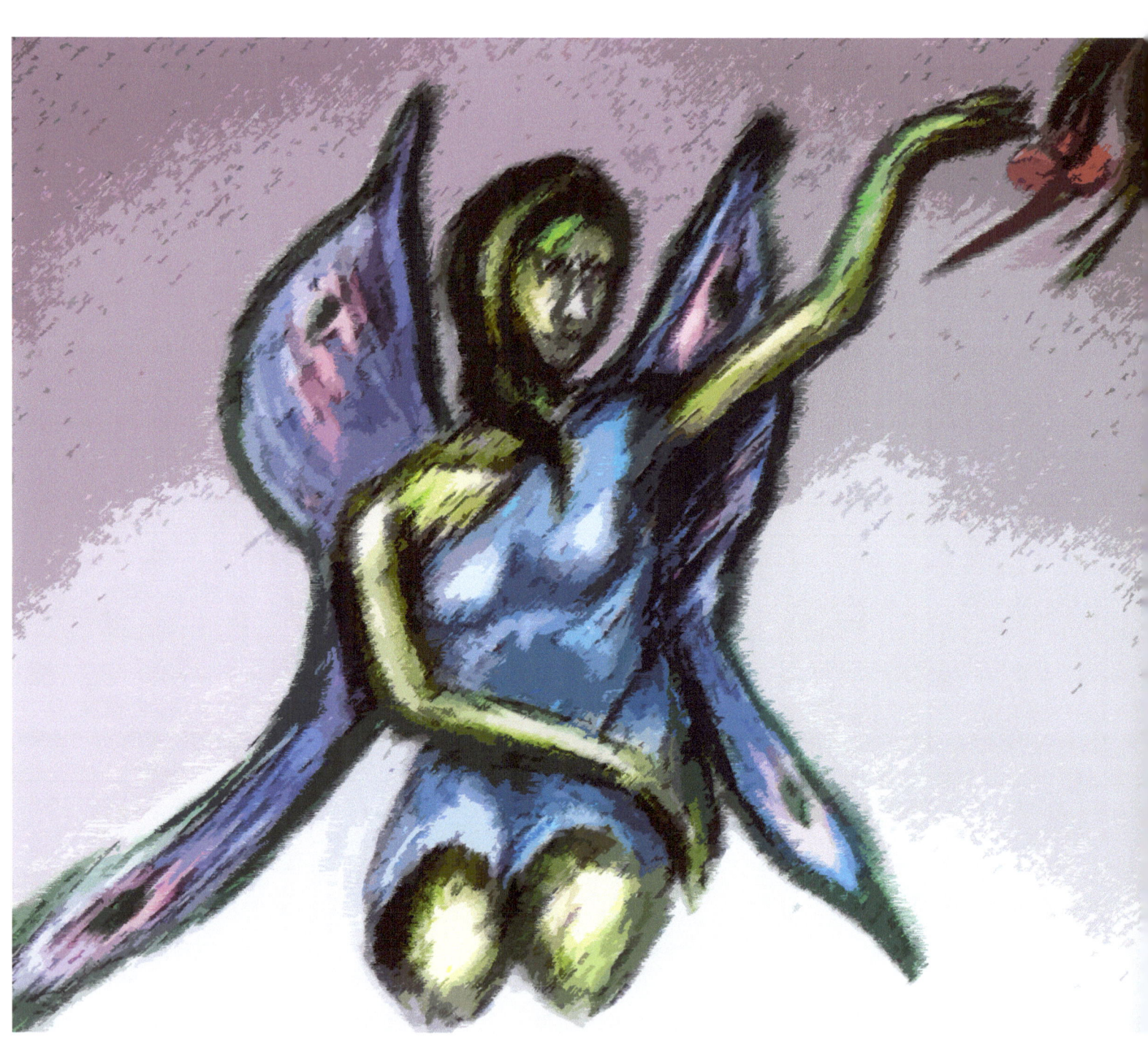

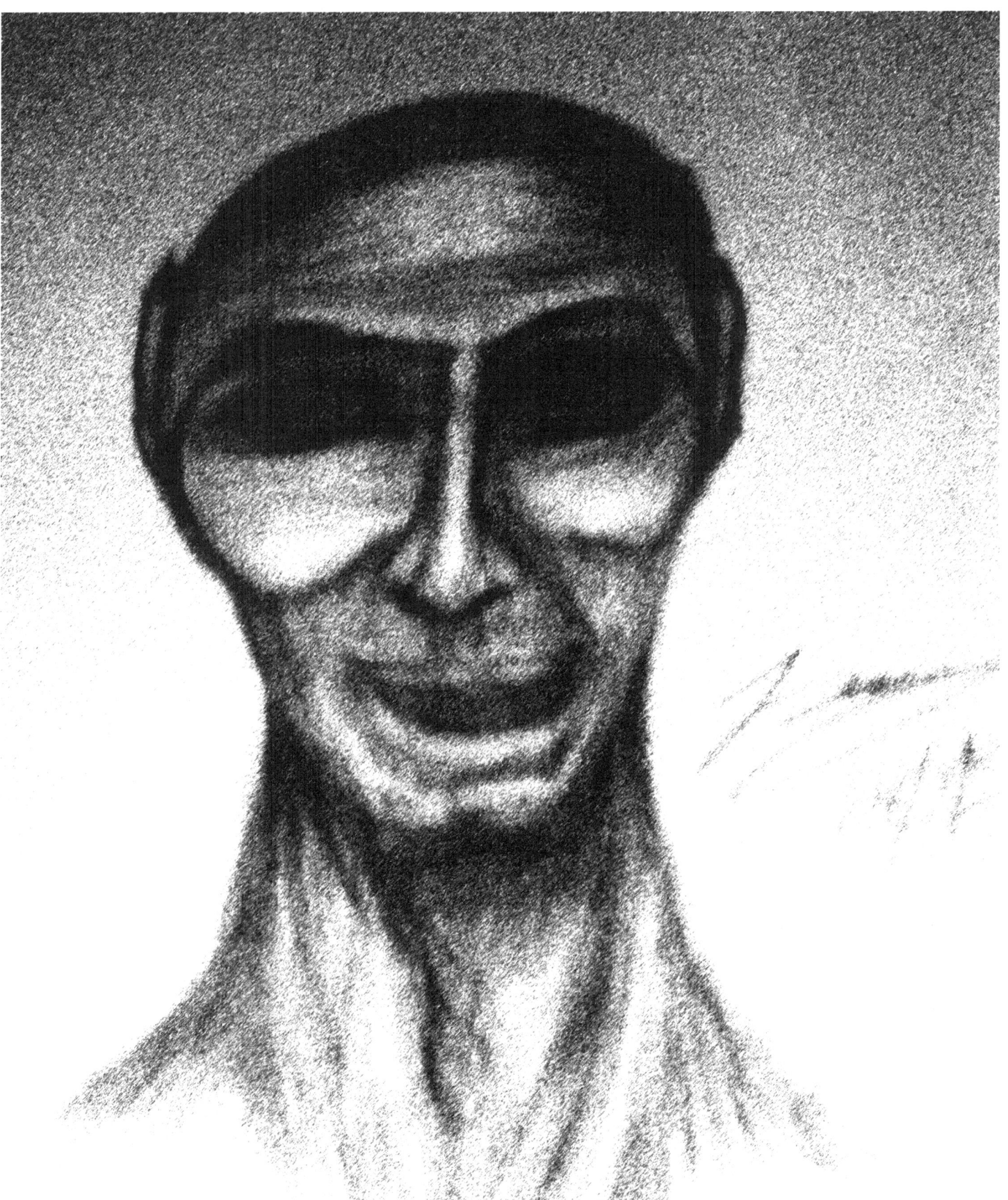

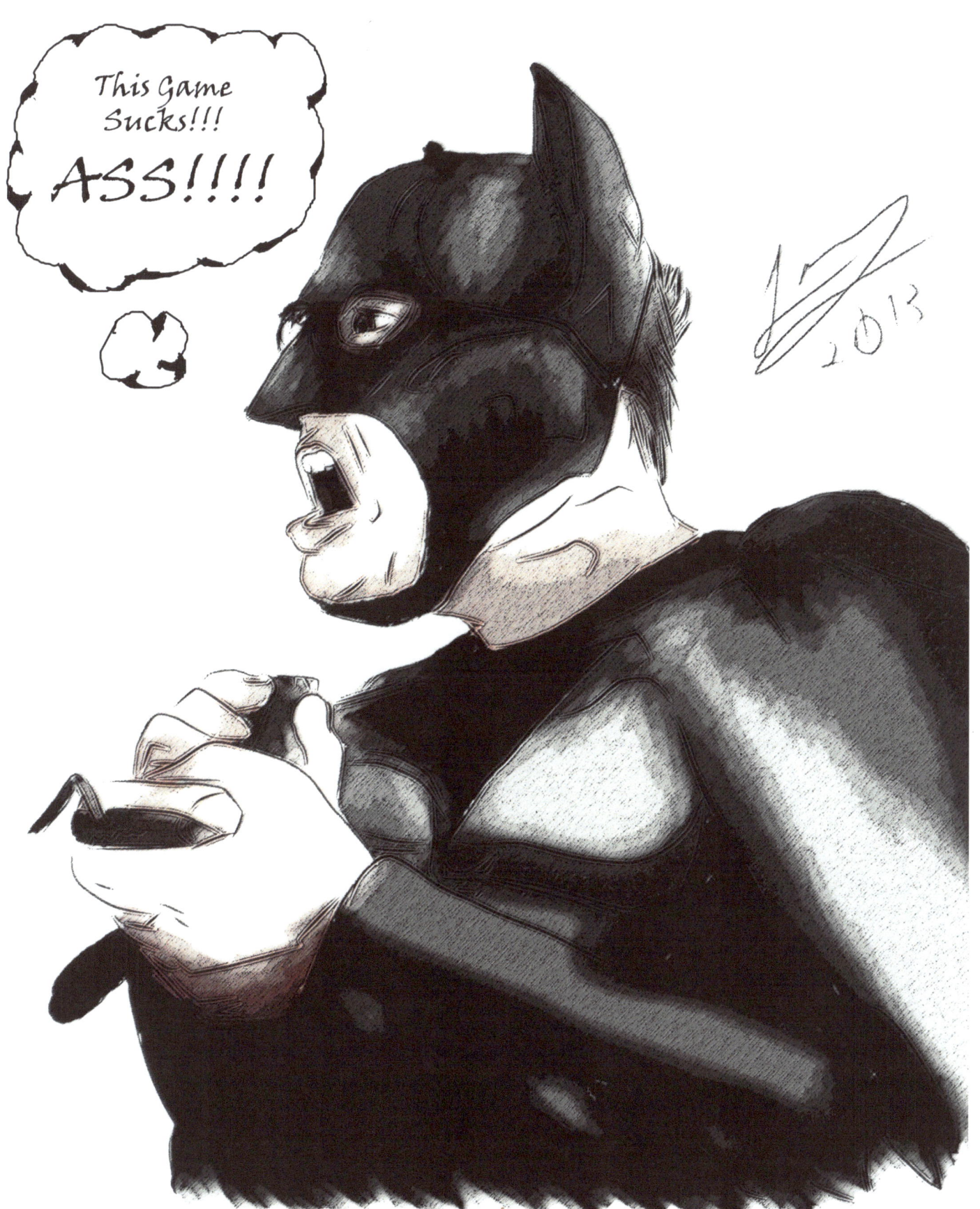

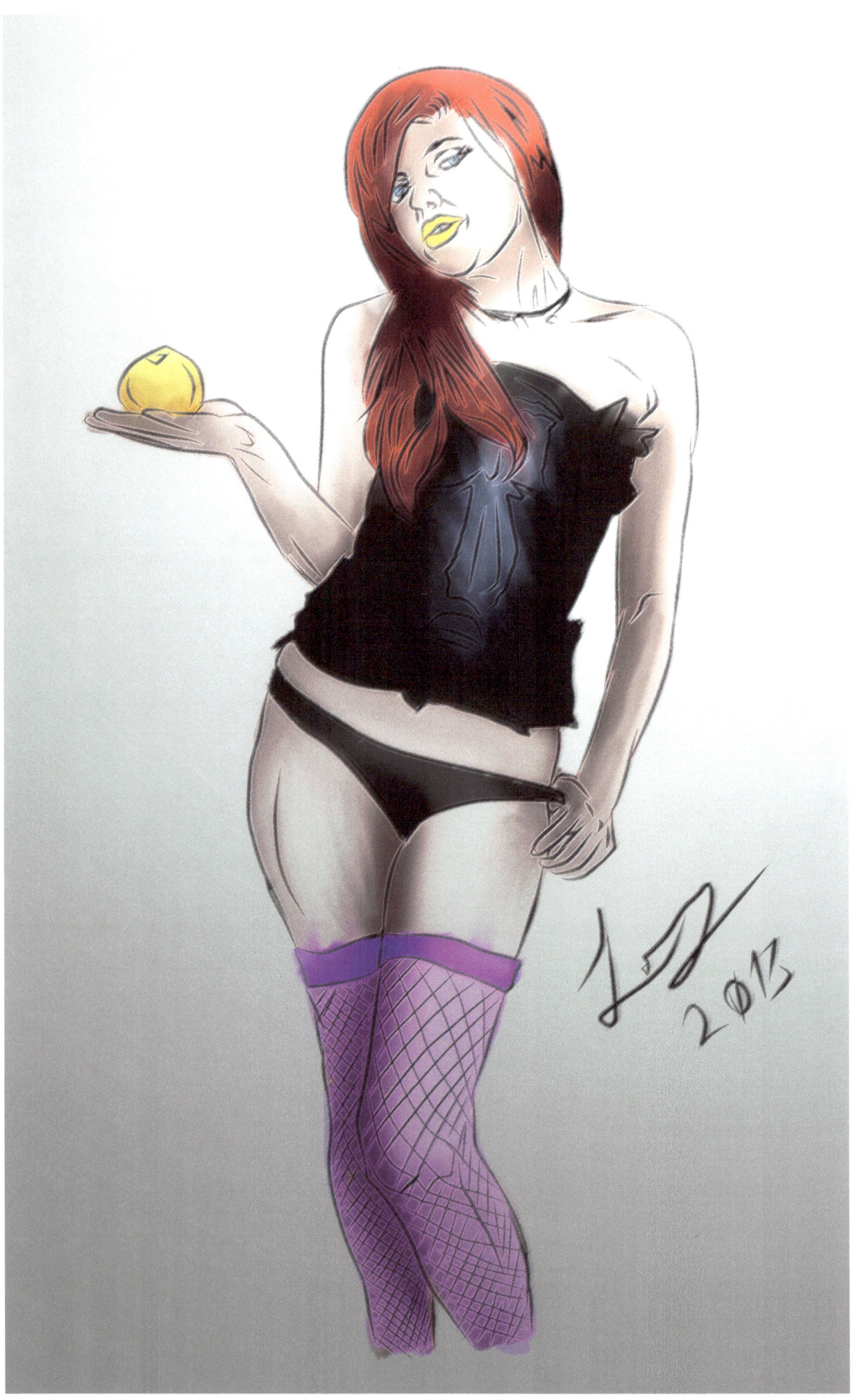

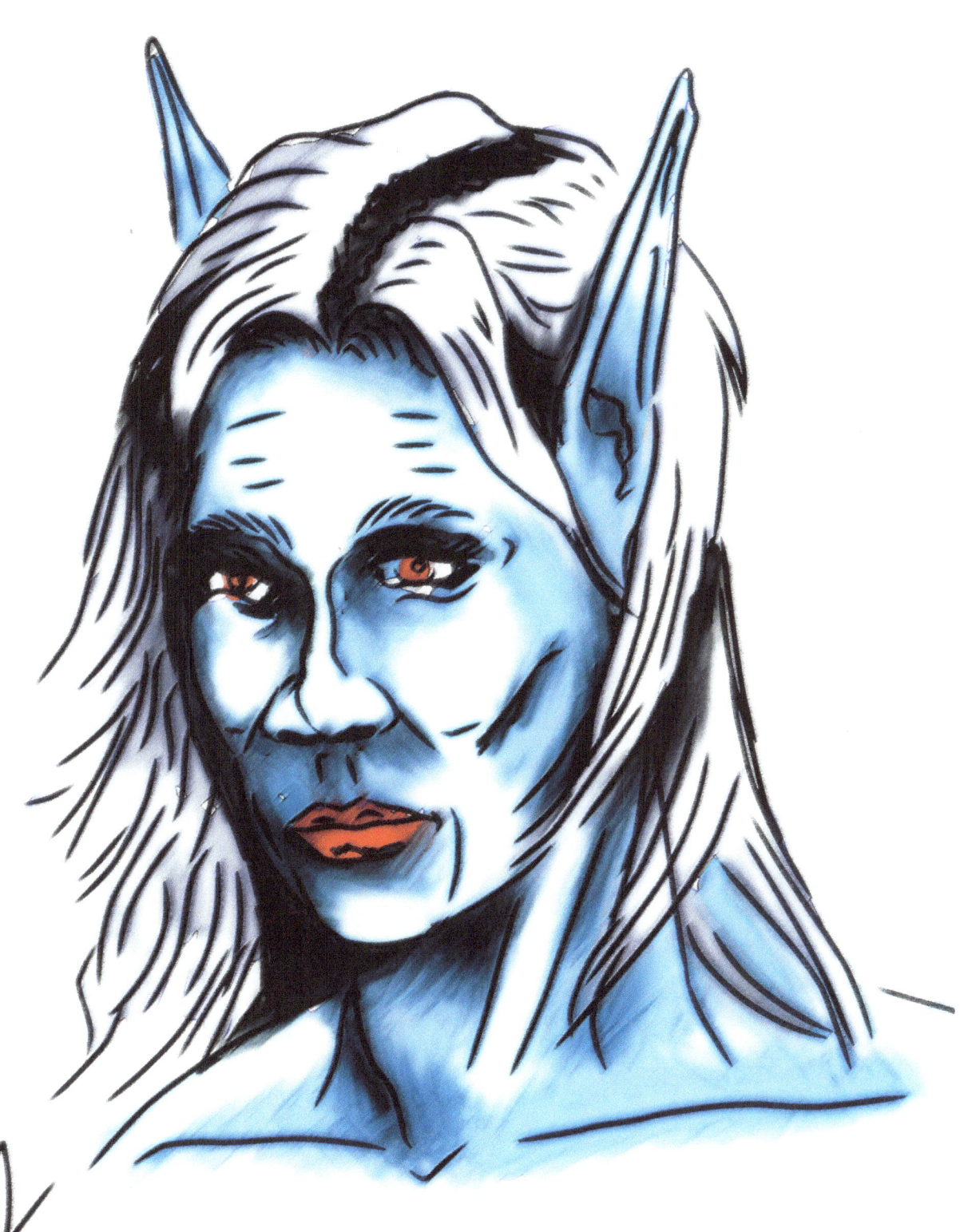

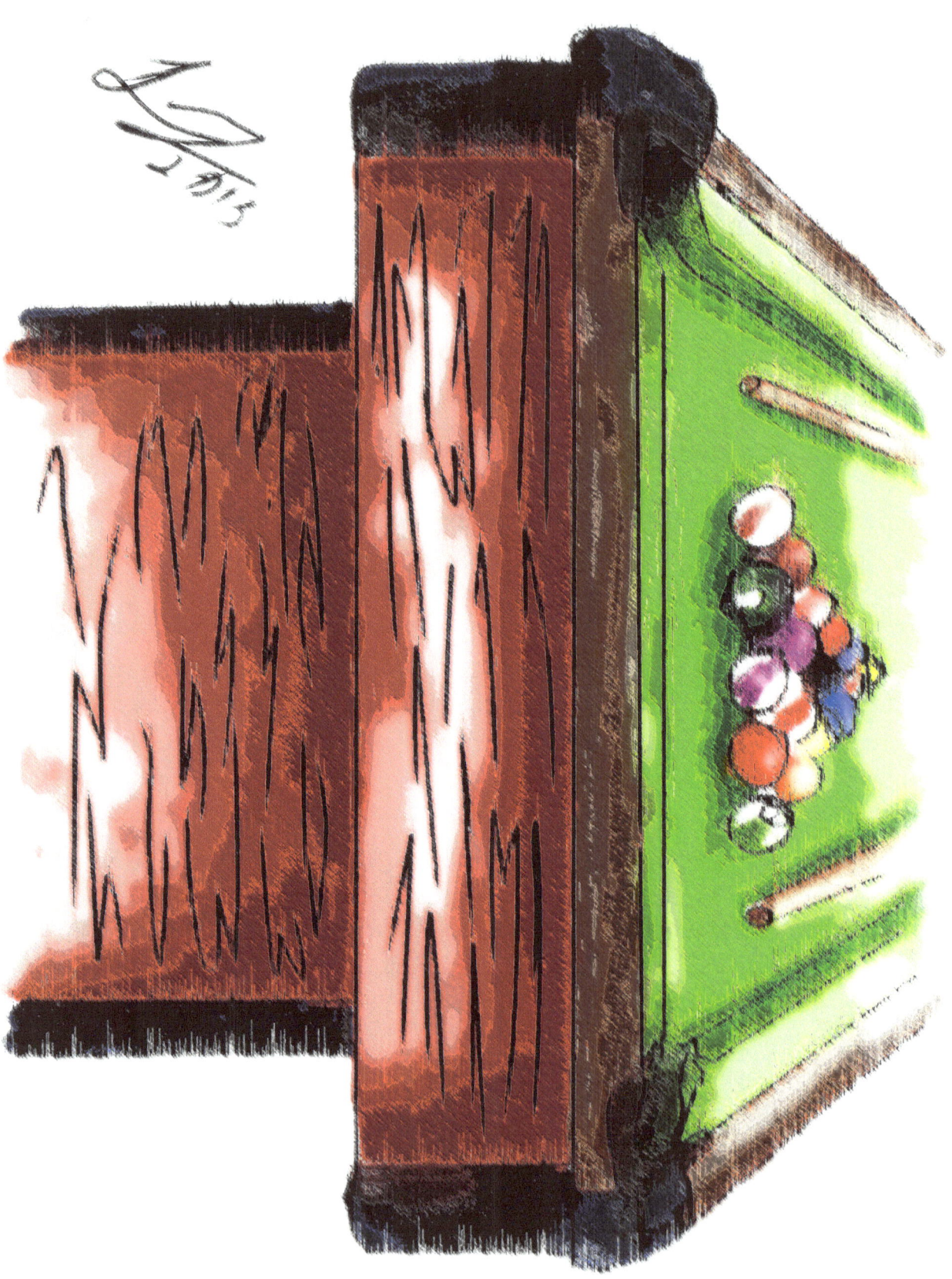

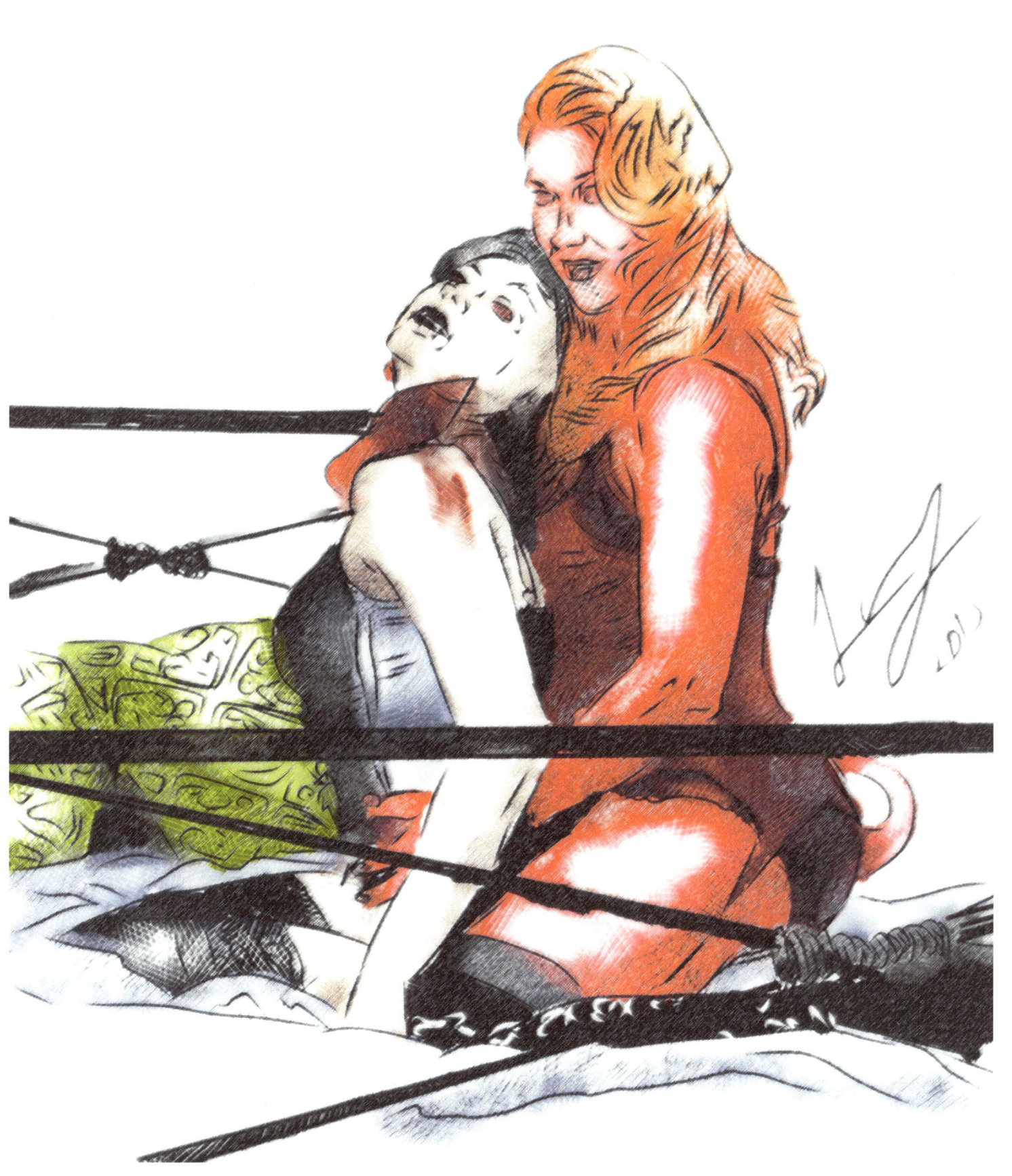

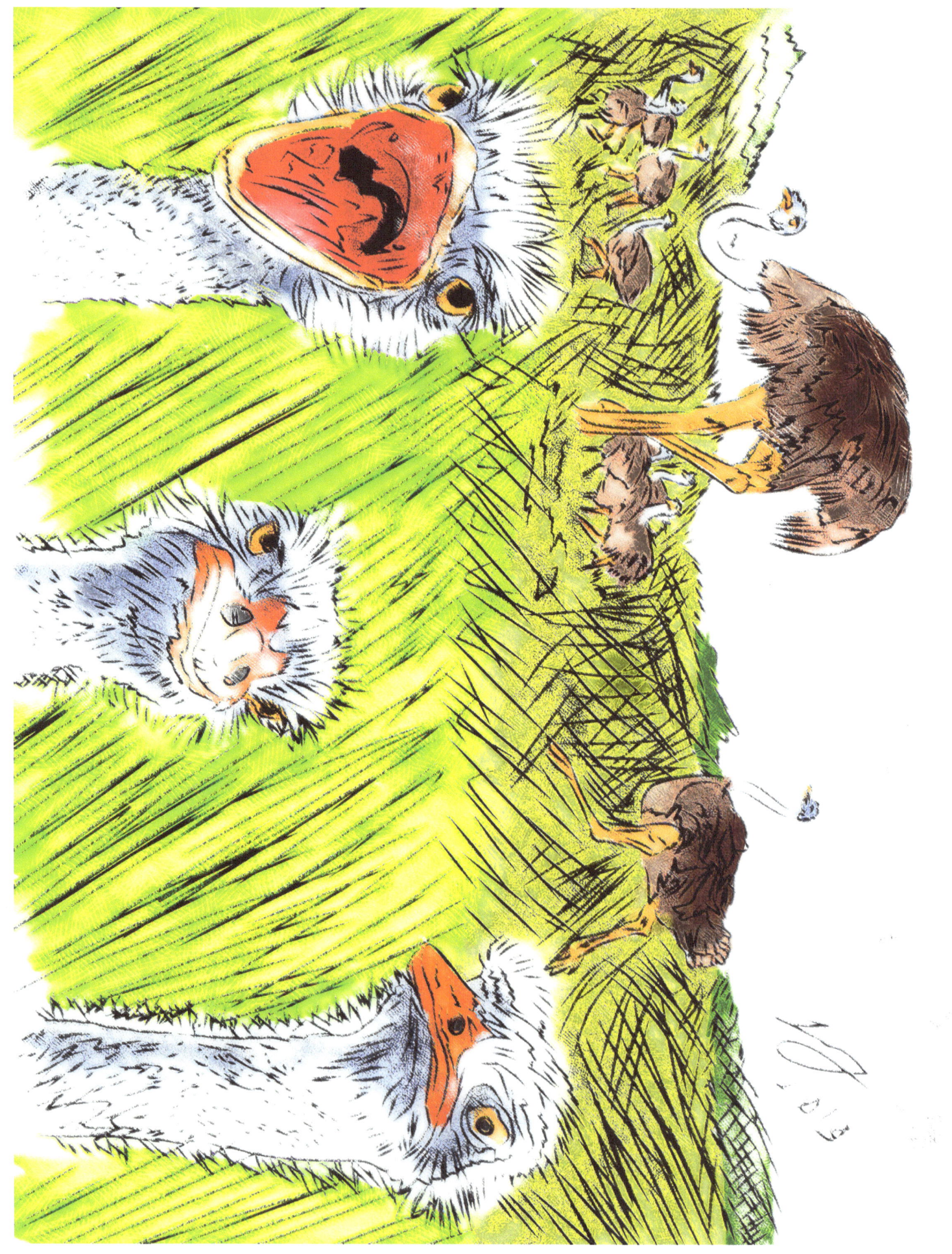

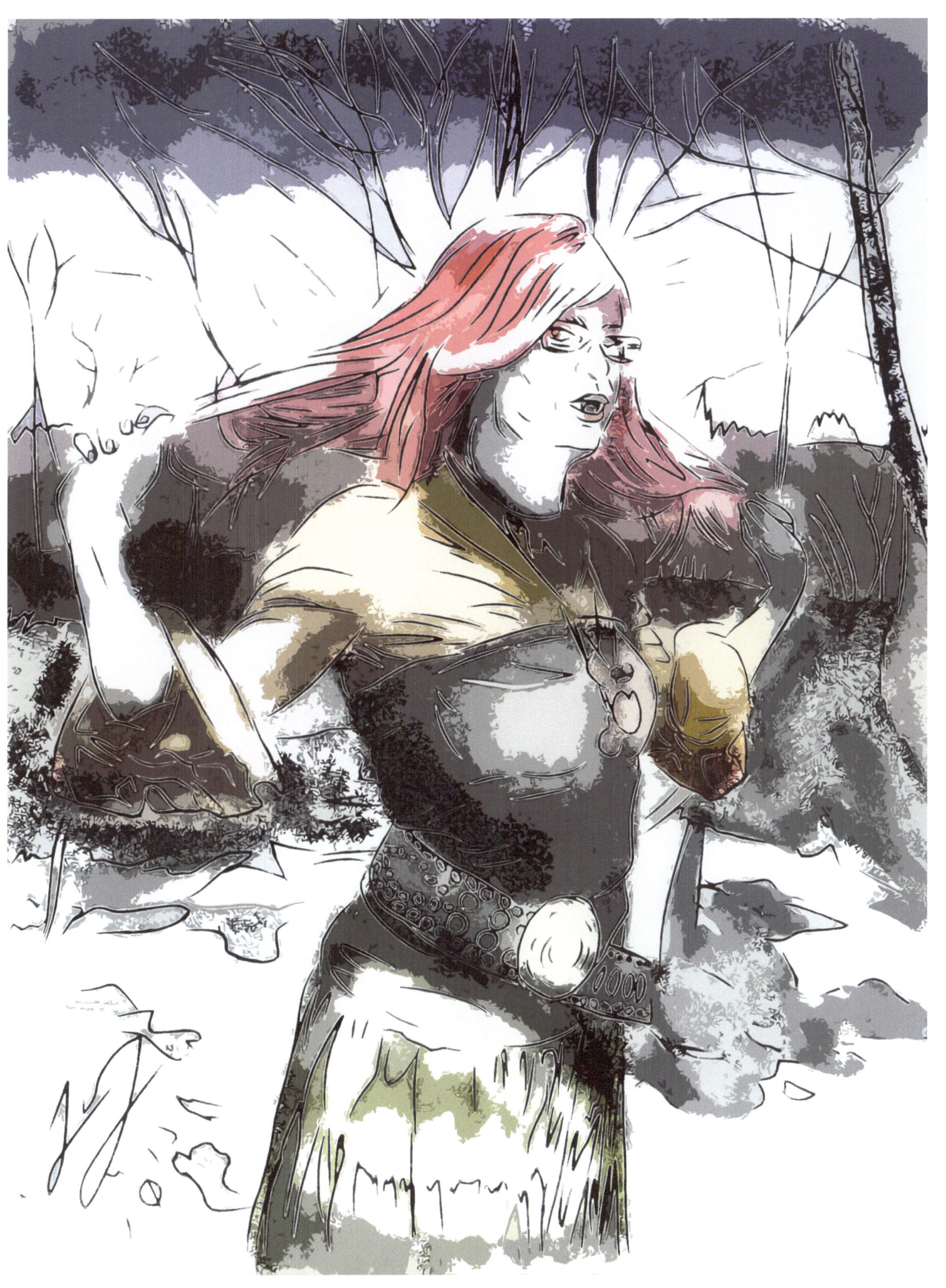

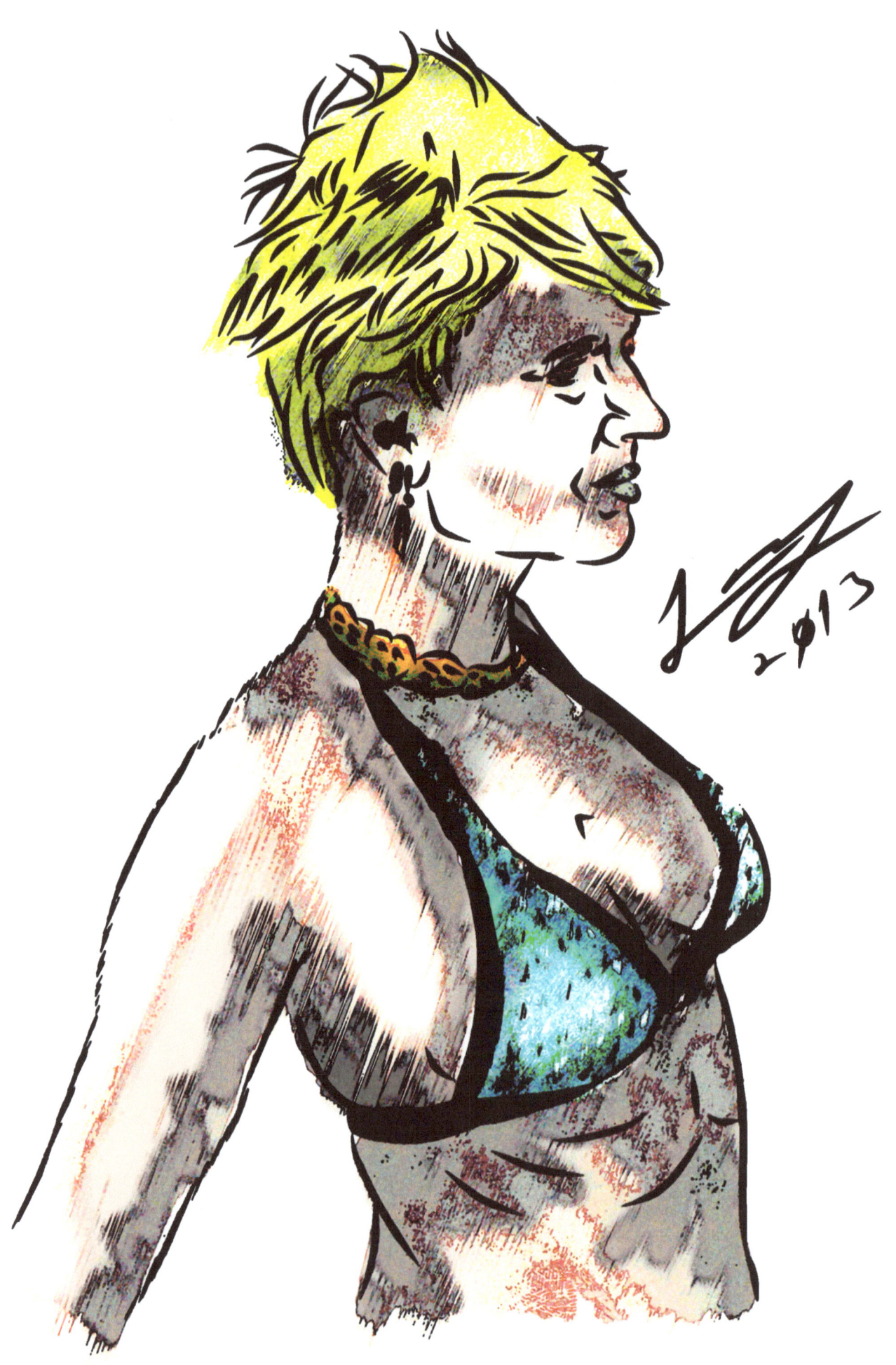

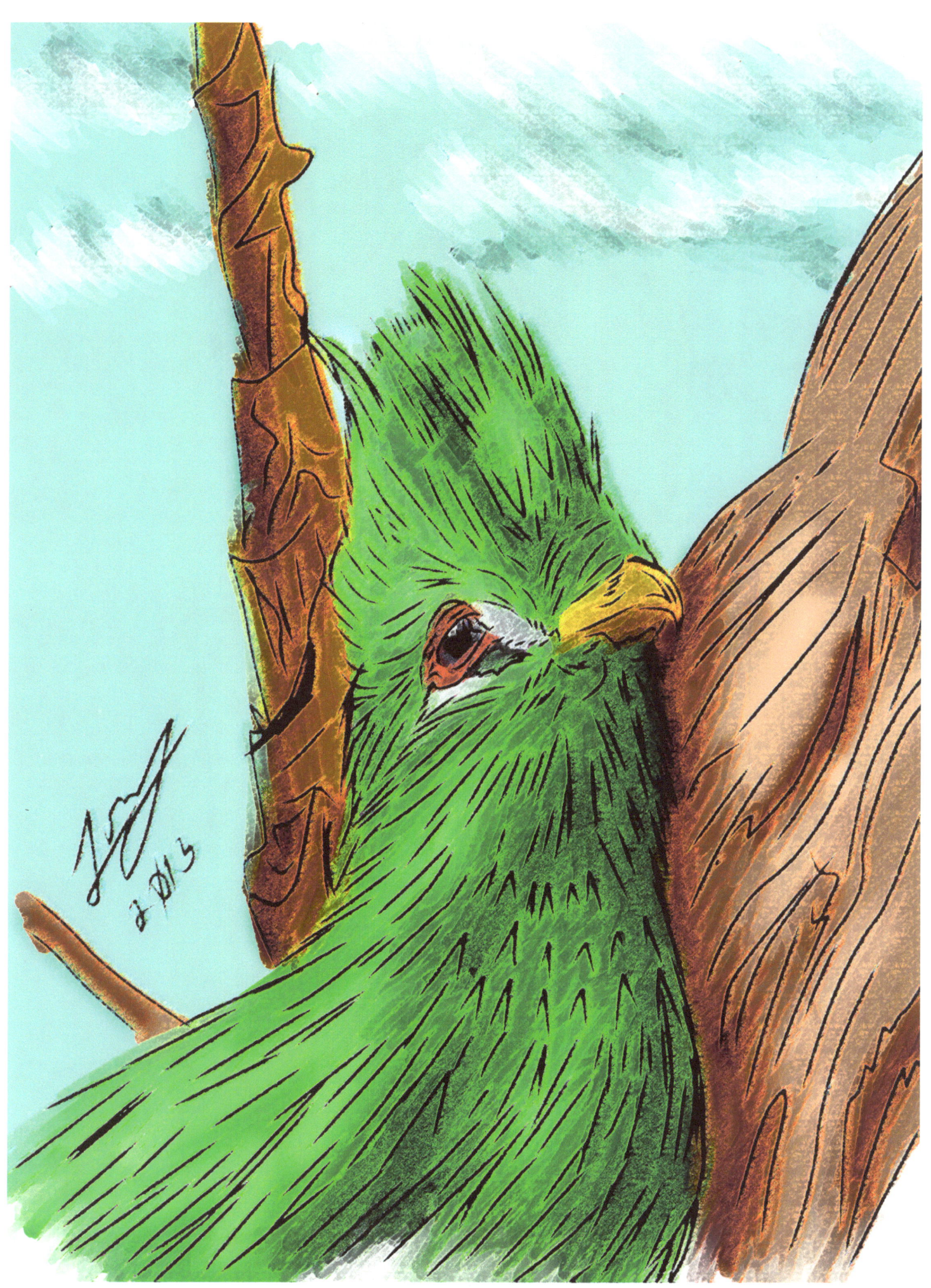

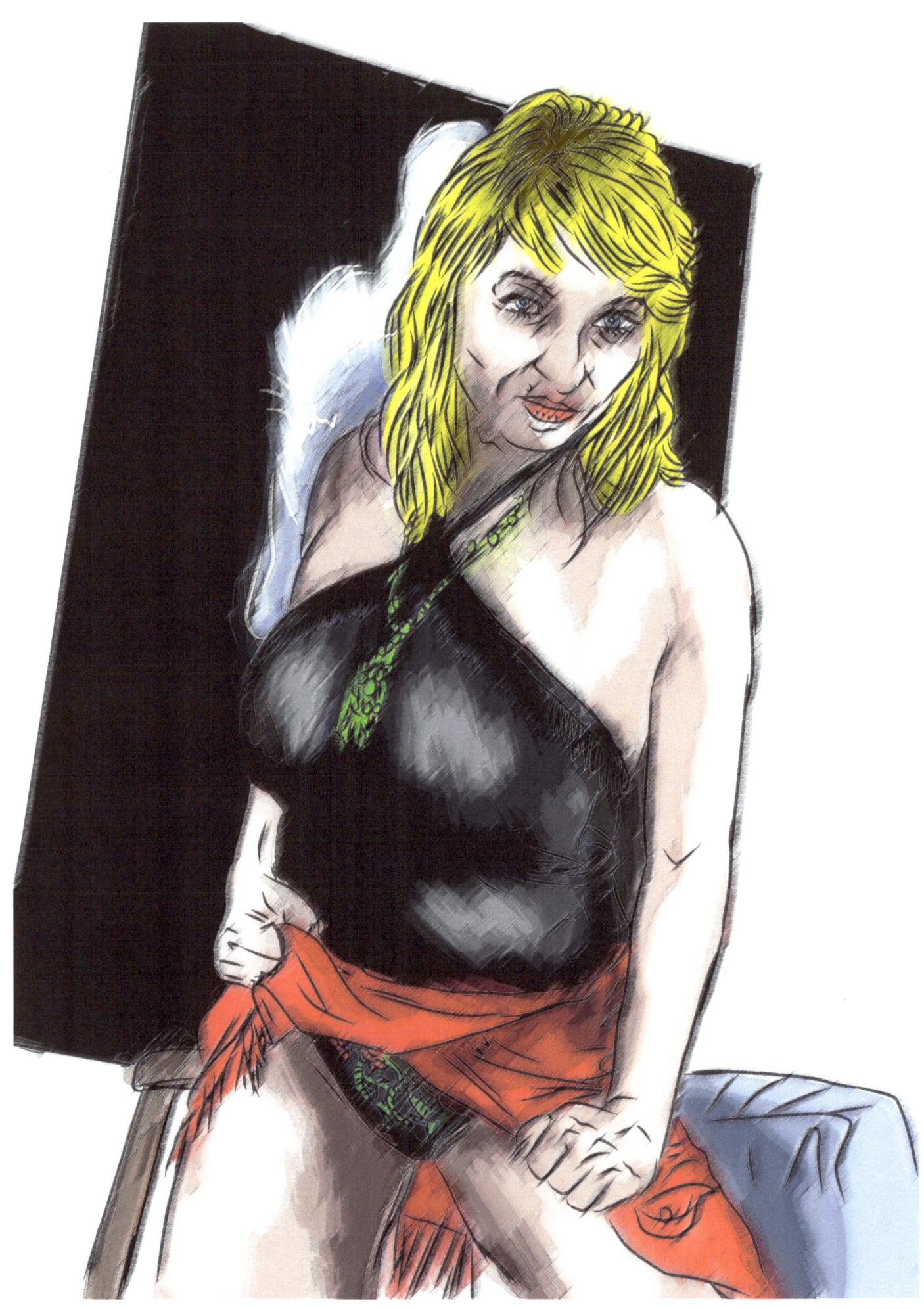

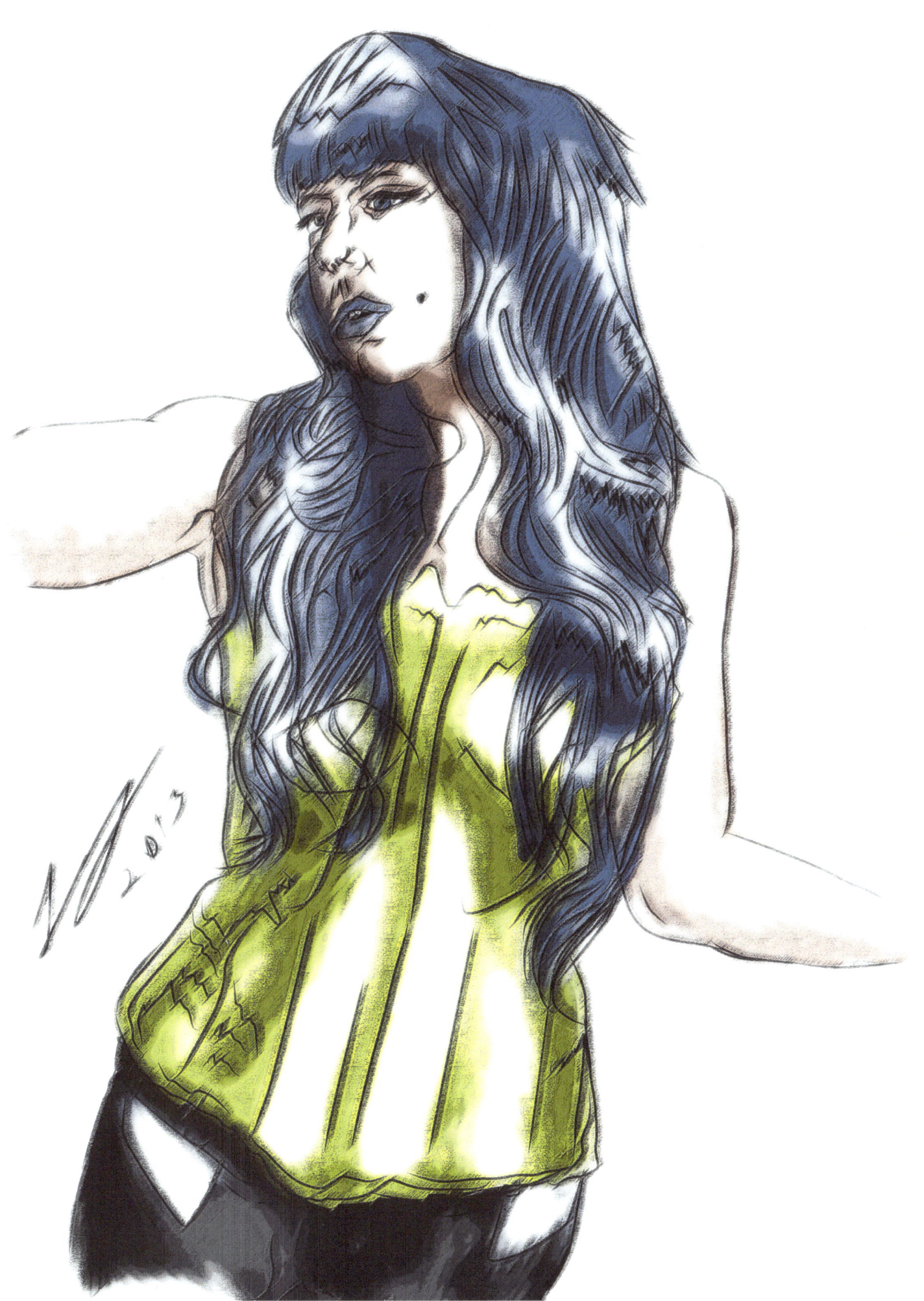

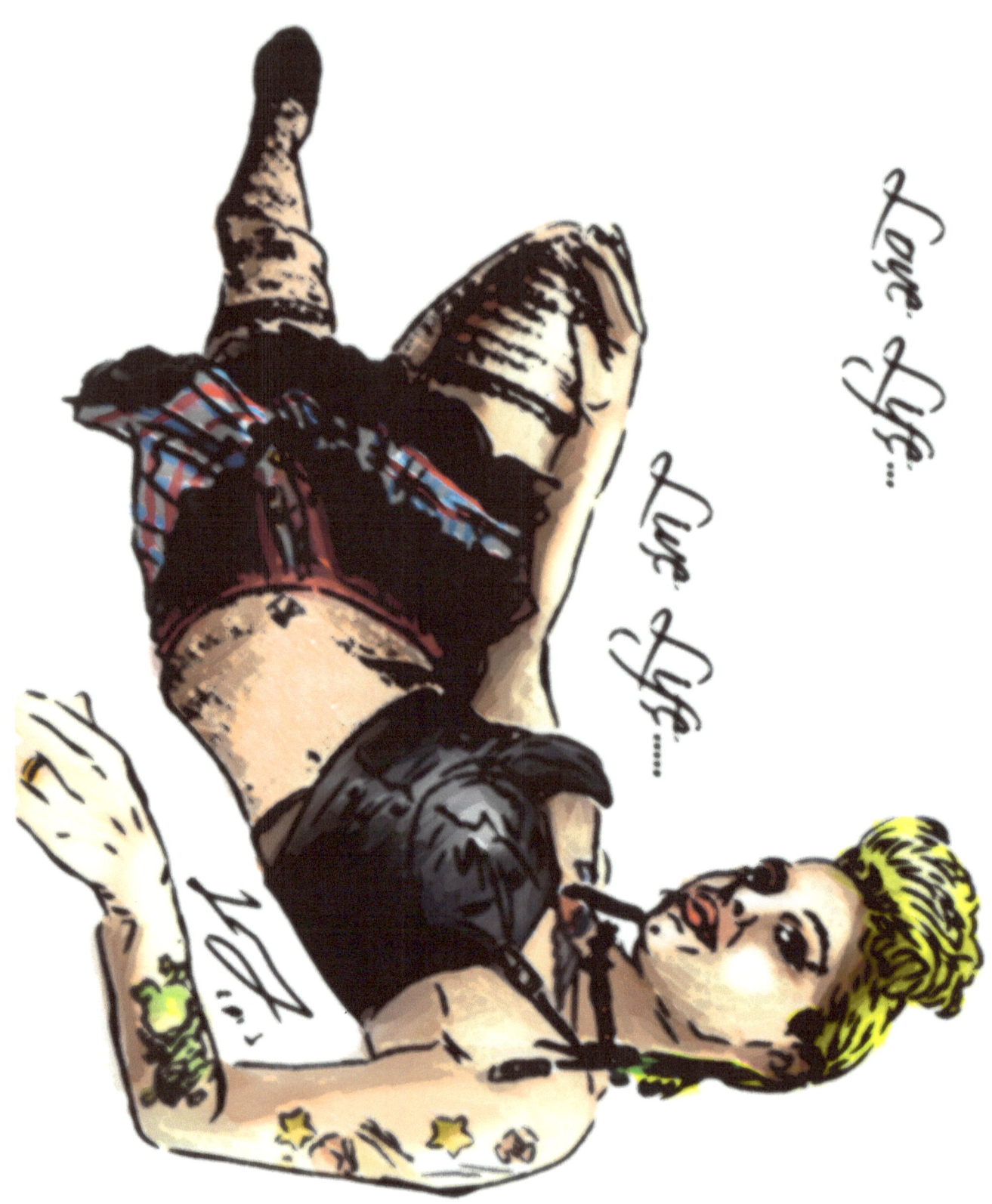

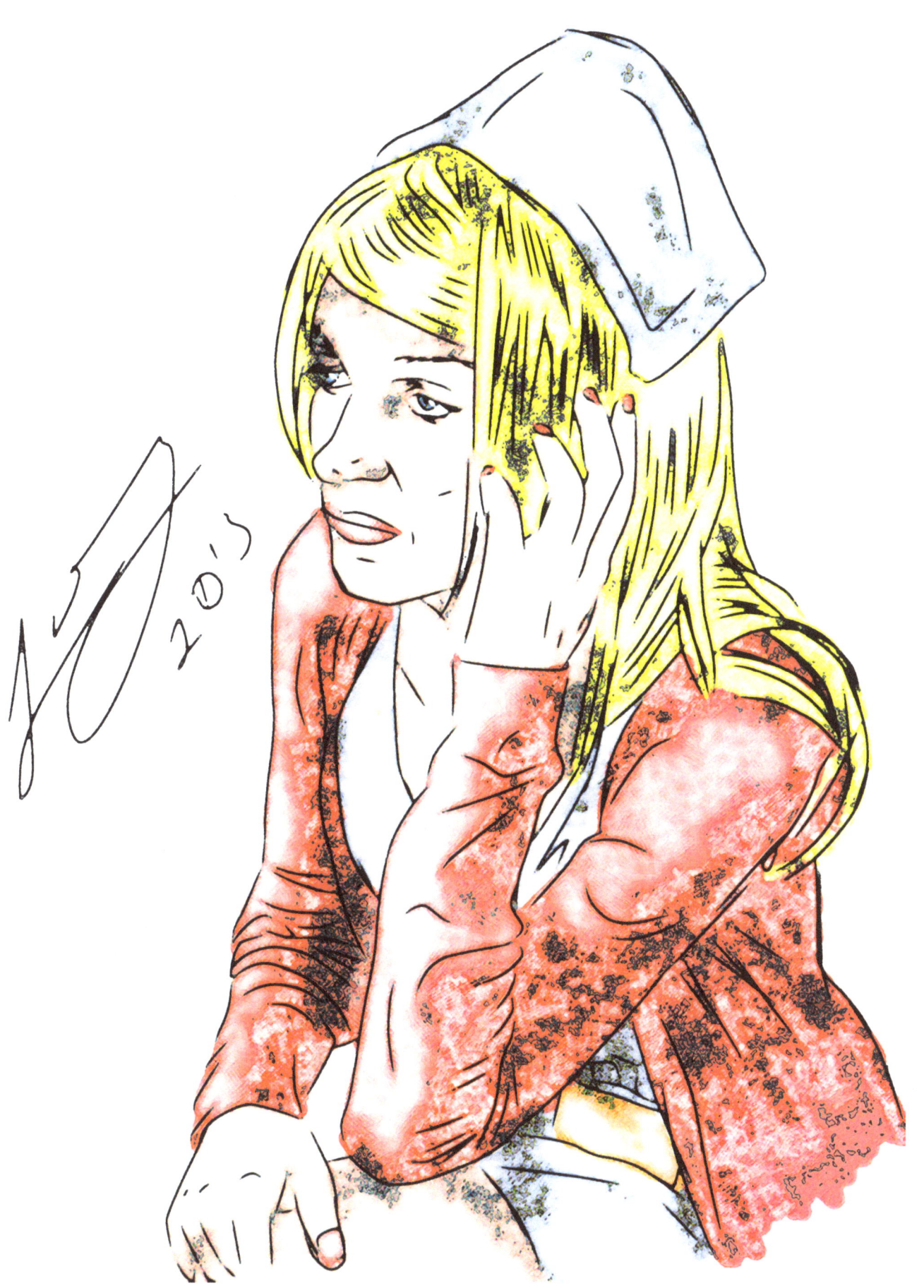

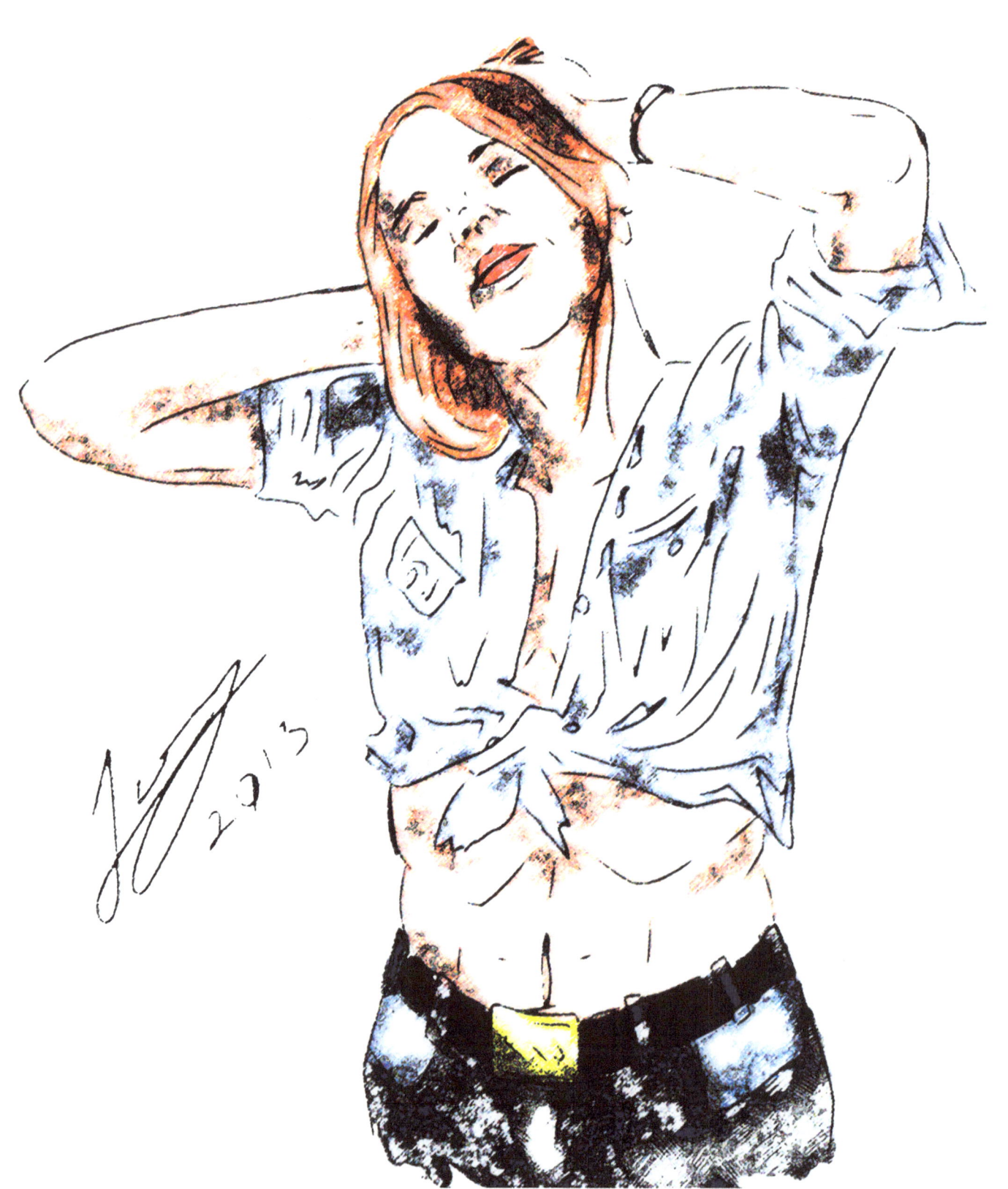

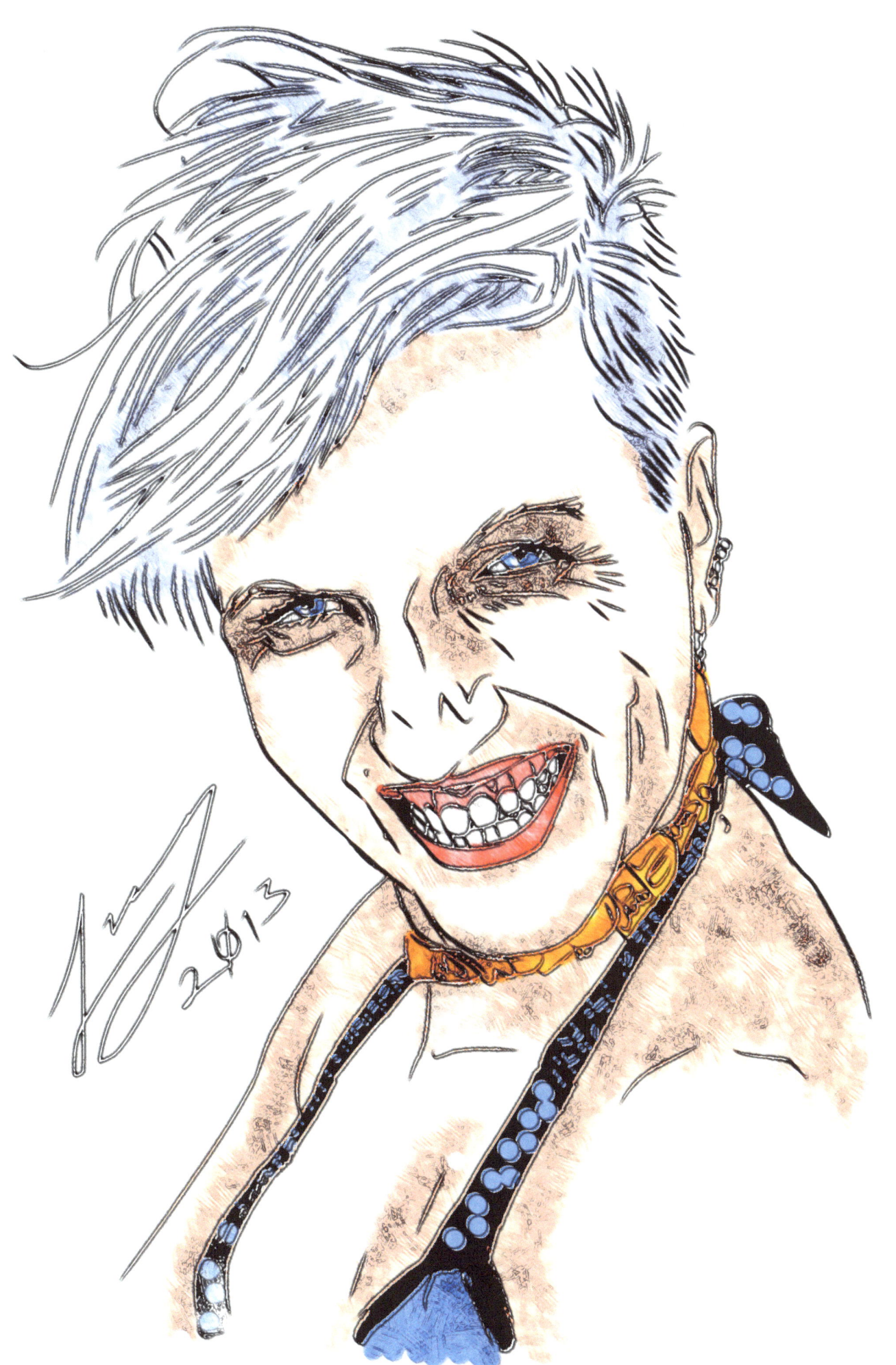

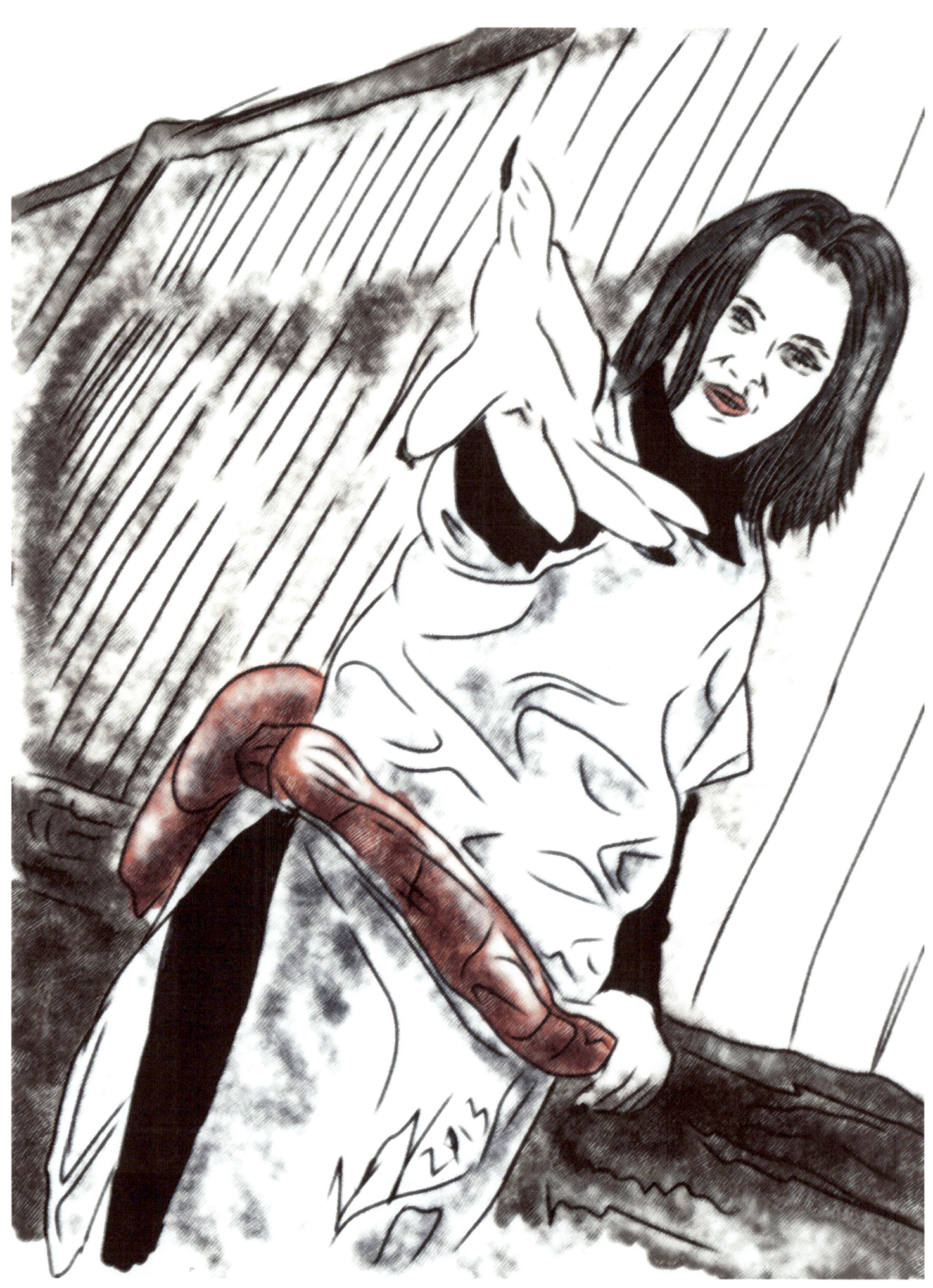

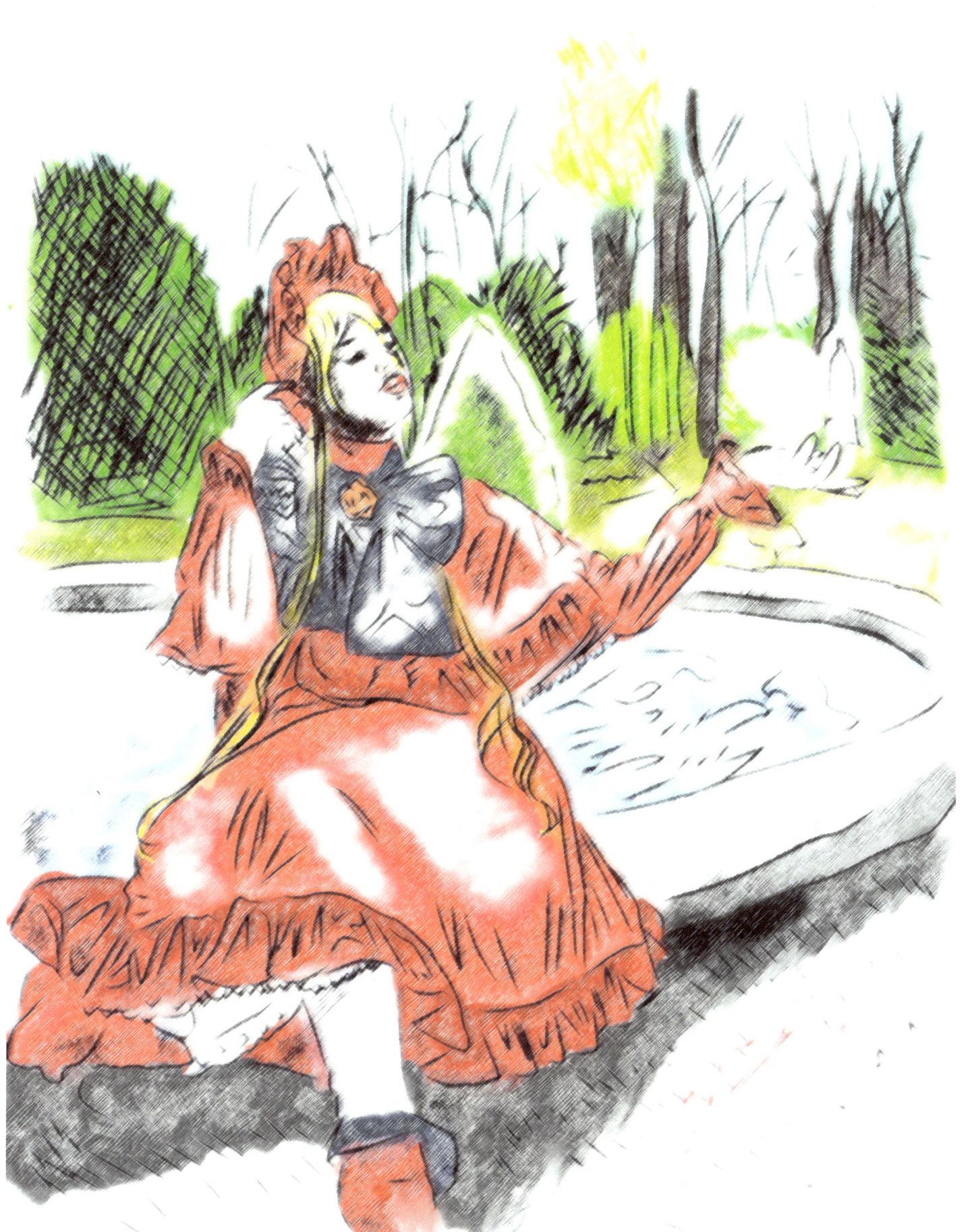

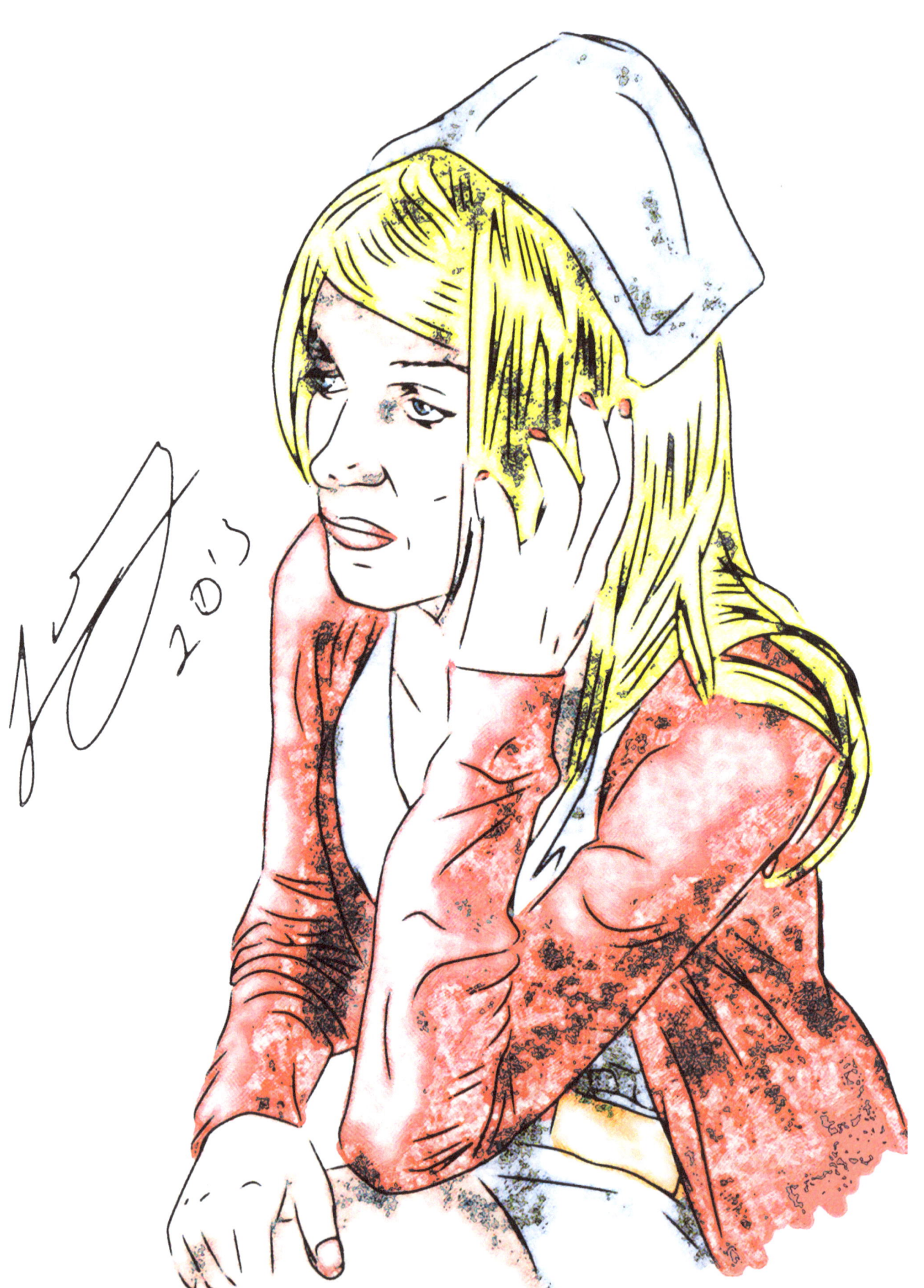

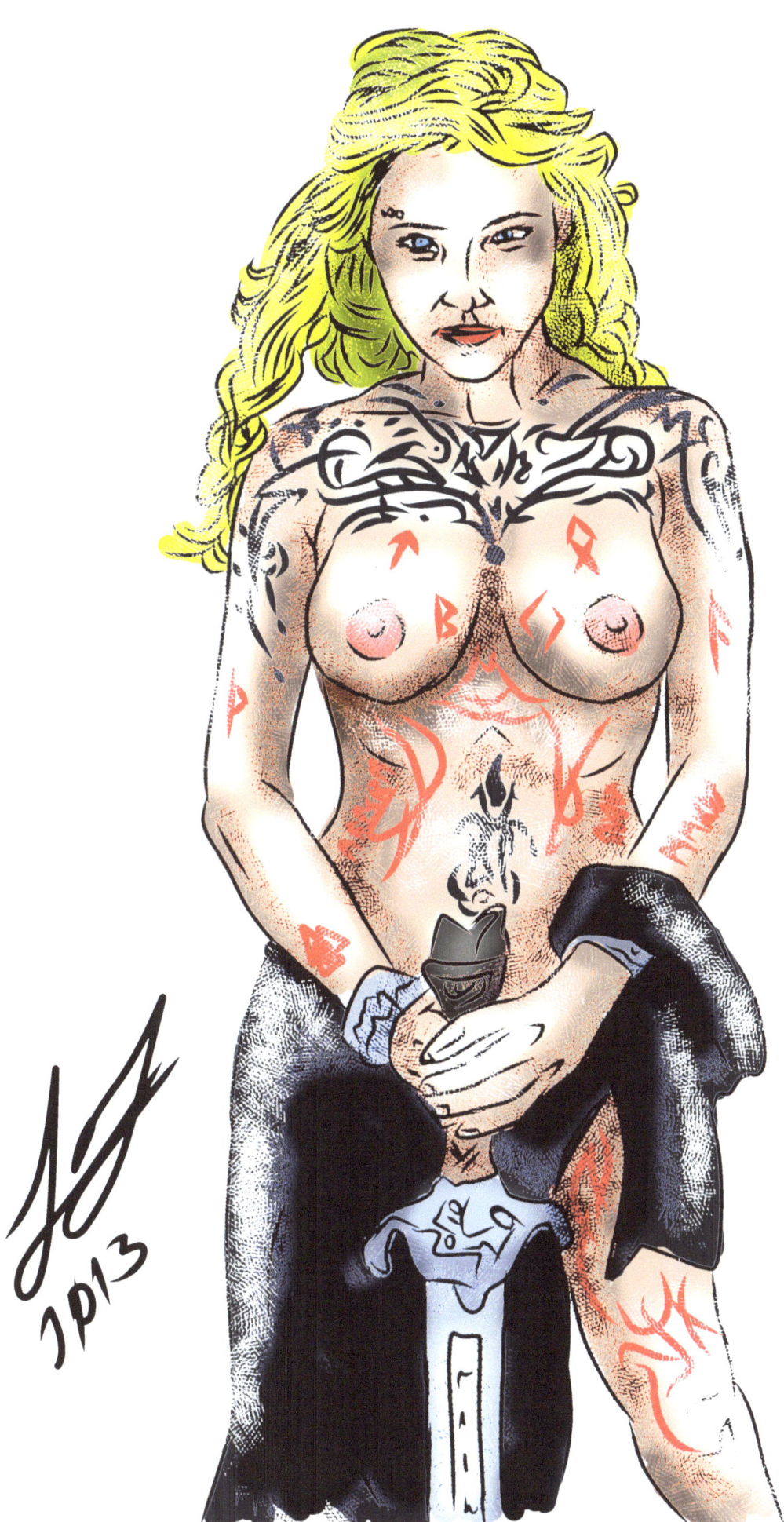

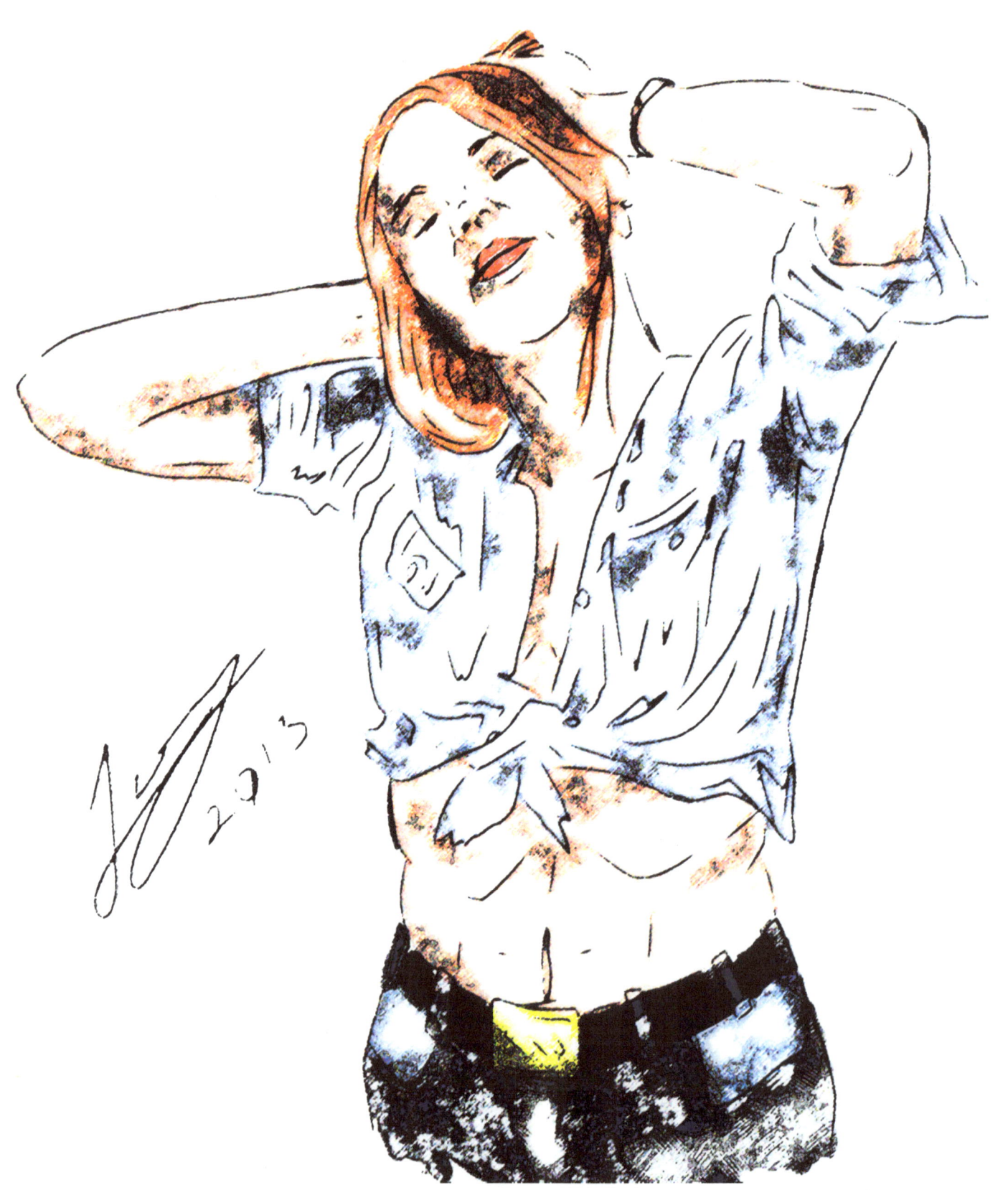

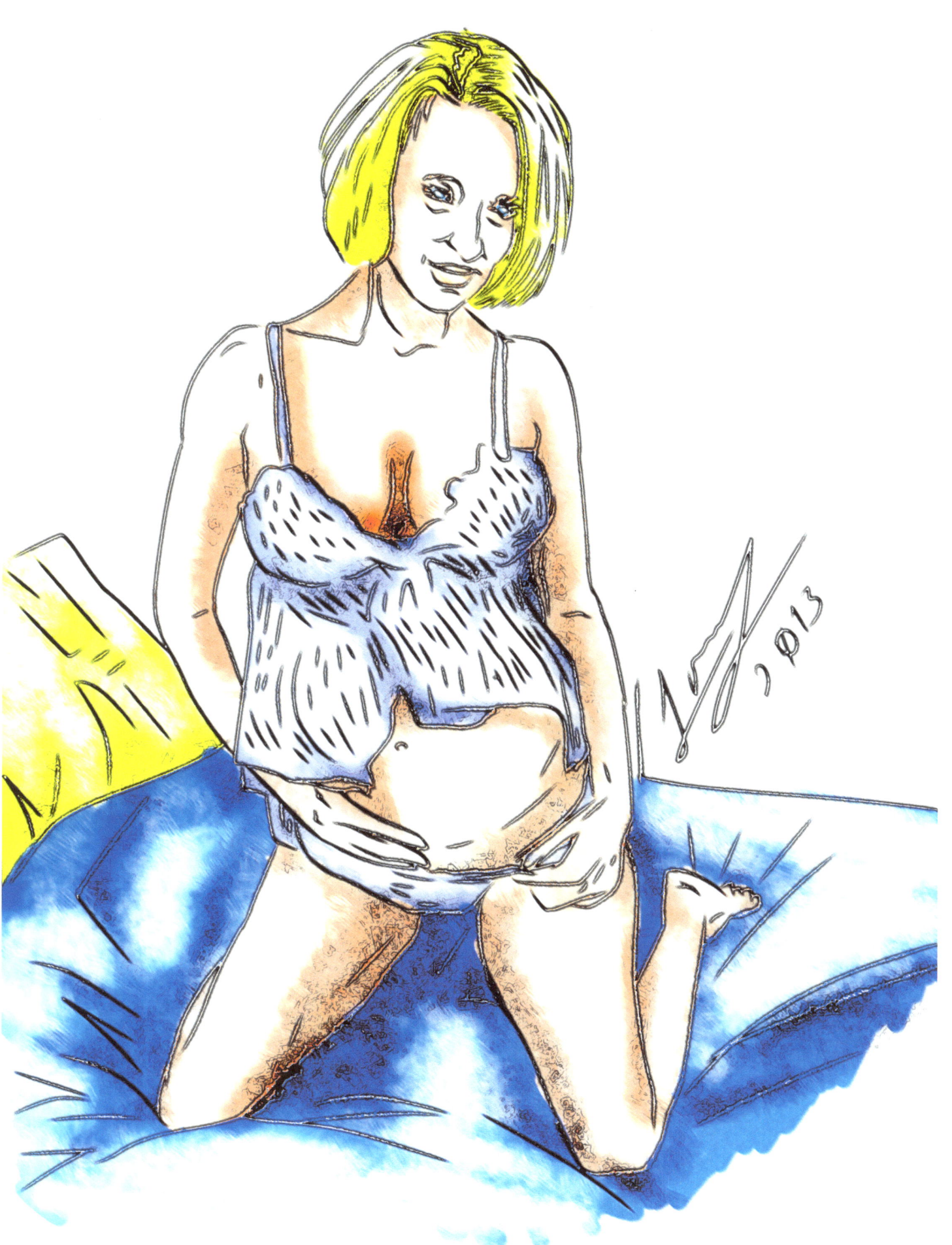

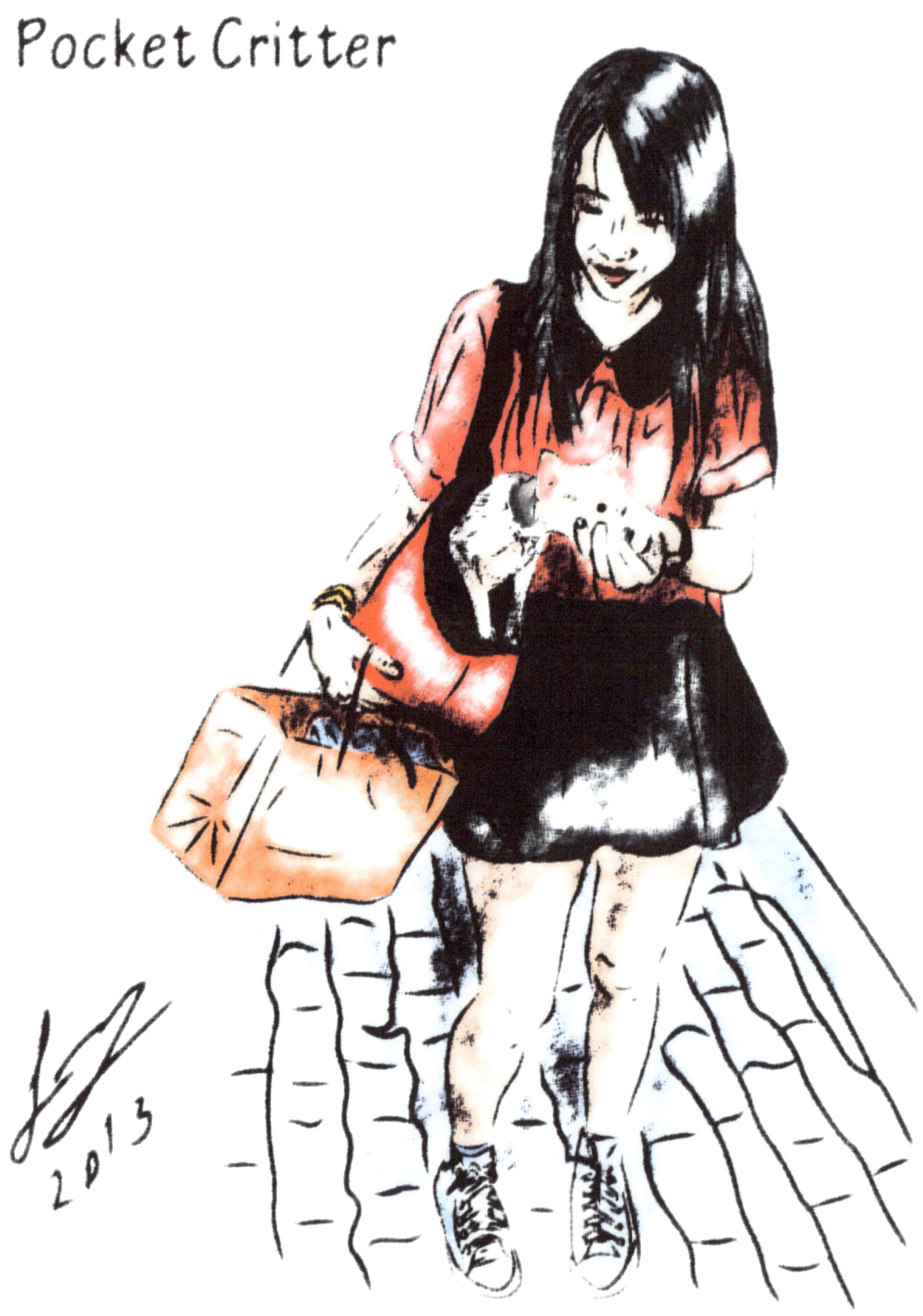

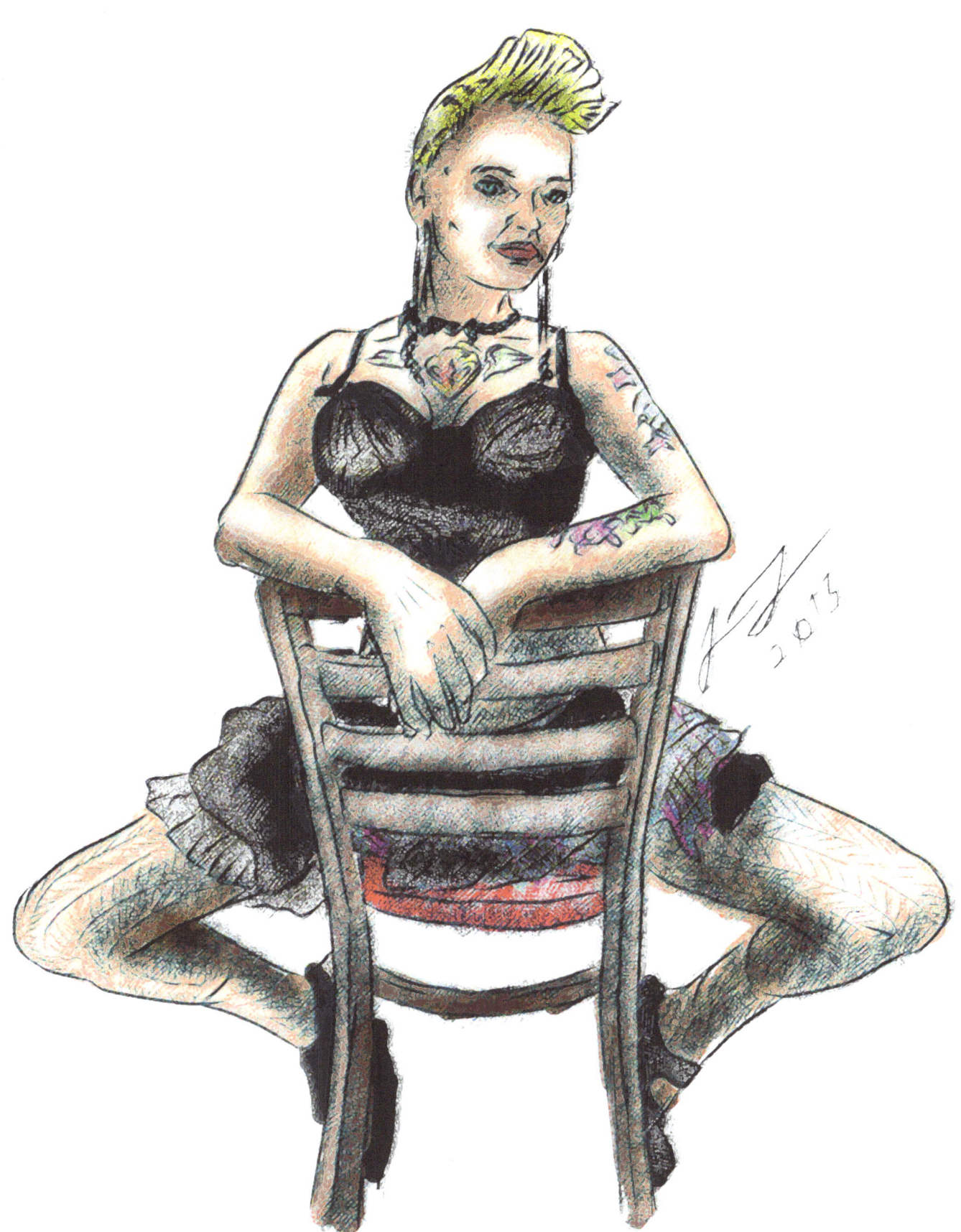

Heathen Art LLC

Benjamin Long, **Illustrator**

The pieces of artwork contained within are the property of Heathen art and Benjamin R Long. No image may be duplicated in part or whole without written permission of Benjamin Long.

Copyrighted images are protected under Title 17 of the USC and traditional copyright applies and duplications must be made in accordance with US law regarding the "Fair use " clause.

Benjamin Long may be contacted on the following Forums:

E-Mail: wiking88142001@yahoo.com

Skype: whitewolfheathen

http://whitewolfheathen.deviantart.com/

Copyright © 2013 (Benjamin Long): All rights reserved.

Commission rates :

Rough Sketch $8 USD

Digital Drawing/Painting $25 USD

Traditional Drawing/Painting on Canvas Panel 8x10 $35 USD

Traditional Drawing/Painting on Canvas Panel 16x20 $80 USD

www.ingramcontent.com/pod-product-compliance
Lightning Source LLC
Chambersburg PA
CBHW050355180526
45159CB00005B/2025